Wabi Sabi

侘寂

WABI SABI

THE JAPANESE ART OF IMPERMANENCE

ANDREW JUNIPER

TUTTLE Publishing

Tokyo | Rutland, Vermont | Singapore

Published by Tuttle Publishing, an imprint of Periplus Editions (HK) Ltd.

www.tuttlepublishing.com

Copyright © 2003 Andrew Juniper

Library of Congress Cataloging-in-Publication Data

Juniper, Andrew, 1967-
 Wabi sabi: the Japanese art of impermanence / Andrew Juniper.— 1st ed.
 ix, 165 p. : ill. ; 23 cm.

 Includes bibliographical references (p.).
 ISBN 0-8048-3482-2 (pbk.)
 1. Art, Japanese. 2. Wabi. 3. Sabi. 4. Art and philosophy. I. Title.
 N7350.J77 2003
 701'.17'0952—dc21 2003054049

ISBN 978-0-8048-3482-7
ISBN 978-4-8053-1548-4 (for sale in Japan only)

Distributed by

North America, Latin America, and Europe
Tuttle Publishing
364 Innovation Drive
North Clarendon, VT 05759-9436 U.S.A.
Tel: 1 (802) 773-8930
Fax: 1 (802) 773-6993
info@tuttlepublishing.com
www.tuttlepublishing.com

Japan
Tuttle Publishing
Yaekari Building, 3rd Floor
5-4-12 Osaki Shinagawa-ku
Tokyo 141 0032
Tel: (81) 03 5437-0171
Fax: (81) 03 5437-0755
sales@tuttle.co.jp
www.tuttle.co.jp

Asia Pacific
Berkeley Books Pte. Ltd.
3 Kallang Sector #04-01/02
Singapore 349278
Tel: (65) 67412178
Fax: (65) 67412179
inquiries@periplus.com.sg
www.tuttlepublishing.com

First edition
26 25 24 23	18 17 16	ISBN 978-0-8048-3482-7
26 25 24 23	6 5 4 3	ISBN 978-4-8053-1548-4 (for sale in Japan only)
Printed in China	2309CM	

Tuttle Publishing® is a registered trademark of Tuttle Publishing, a division of Periplus Editions (HK) Ltd.

Contents

Spirit

PREFACE

When I found myself bartering for an old oven pot in a Turkish restaurant, I realized that the years spent in Japan had radically and irreversibly changed my perspectives on both art and beauty. The small dark bowl that had so caught my attention had no real design to speak of, its surface was rough and impregnated with years of Turkish cuisine . . . and yet there was something about it that was captivatingly attractive. The glazed surface had become rich with visual nuance and its simple unrefined form was pure and unaffected by artistic considerations—it was one of a thousand similar bowls, but its rusticity and artlessness were extraordinarily expressive and resonated with the imperfections and impermanence of life. The pot we so admired had what the Japanese refer to as *wabi sabi.*

The Turkish restaurateurs who were asked to part with their bowl for a price far greater than that of a replacement thought we were a little strange, to say the least, but happily accepted our eccentricity and payment. Explaining wabi sabi to an English-speaking audience is a challenge, but with a ten-word vocabulary of Turkish it was not a realistic proposition.

Having opened a design gallery called Wabi Sabi in the United Kingdom, not surprisingly we are regularly asked to explain the concept. Yet every attempt to clarify its tenets usually resulted in a slow glazing of the listener's eyes and then silence. This inability to adequately explain wabi sabi continued for several years, until we were approached to write a book on the subject—something most Japanese would

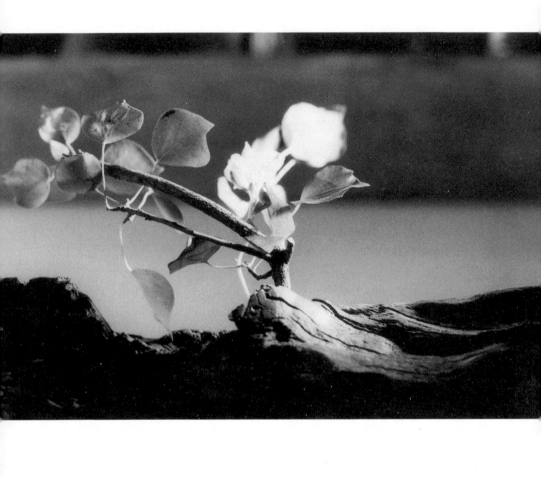

consider unwise to even attempt. Wabi sabi is an aesthetic philosophy so intangible and so shrouded in centuries of mystery that even the most ambitious Japanese scholars would give it a wide berth and uphold the Japanese tradition of talking about it only in the most poetic terms. The Japanese have an admirable tendency to leave the unexplainable unexplained, as is the case with Zen, whose most profound teachings cannot be communicated by verbal explanations. Zen believes words are the fundamental obstacle to clear understanding. The monks seek to reach their goal of enlightenment not through learning but by the unlearning of all preconceived notions of life and reality.

However, for those in the West who are interested in things Japanese, there needs to be some form of entry into the Japanese worldview and a way to share their aesthetic ideals. This book then is an attempt to clarify and illustrate some of the ideas that form the foundation for wabi sabi art. As Zen and Christianity differ profoundly, so do the philosophies that have guided the development of art under the two cultural banners.

Zen monks lead a simple and austere life constantly aware of their mortality. Wabi sabi art is a distillation of their humble efforts to try and express, in a physical form, their love of life balanced against the sense of serene sadness that is life's inevitable passing. As the artistic mouthpiece of the Zen movement, wabi sabi art embodies the lives of the monks and is built on the precepts of simplicity, humility, restraint, naturalness, joy, and melancholy as well as the defining element of impermanence. Wabi sabi art challenges us to unlearn our views of beauty and to rediscover the intimate beauty to be found in the smallest details of nature's artistry.

Wabi sabi does not yield easily to a definitive, one-line interpretation, but the author hopes that through the pages of this book the legacy left by the wise Zen monks of old will offer some new perspectives on the spirituality of art in a world moving rapidly toward unrestrained materialism.

INTRODUCTION

Long ago a man out walking encountered a hungry tiger, which proceeded to chase and corner him at the edge of a small precipice. The man jumped to avoid the impending danger and in so doing managed to catch the limb of a tree growing from the small escarpment. While he hung there he became aware of a second tiger, this one at the foot of the precipice, waiting for him to fall. As his strength began to wane the man noticed a wild strawberry that was growing within his reach. He gently brought it to his lips in the full knowledge that it would be the last thing that he ever ate—how sweet it was.

WABI SABI is in many ways like the bittersweet taste of the last strawberry in this old Zen tale. It is an expression of the beauty that lies in the brief transition between the coming and going of life, both the joy and melancholy that make up our lot as humans.

Wabi sabi is an aesthetic ideal and philosophy that is best understood in terms of the Zen philosophy that has nurtured and molded its development over the last thousand years. Zen seeks artistic expression in forms that are as pure and sublime as the Zen tenets they manifest; it eschews intellectualism and pretense and instead aims to unearth and frame the beauty left by the flows of nature.

Wabi sabi embodies the Zen nihilist cosmic view and seeks beauty in the imperfections found as all things, in a constant state of flux, evolve from nothing and devolve back to nothing. Within this perpetual movement nature leaves arbitrary tracks for us to contemplate,

and it is these random flaws and irregularities that offer a model for the modest and humble wabi sabi expression of beauty. Rooted firmly in Zen thought, wabi sabi art uses the evanescence of life to convey the sense of melancholic beauty that such an understanding brings.

As early as the thirteenth century Zen monks combined the worlds of art and philosophy into a symbiotic whole where the functions and goals of the two became almost inseparable. Since then, Japanese culture has been an unstoppable creative force whose influence on world culture and art rival that of any other country. The list of its distinctions—in nearly every sphere of the arts—is quite astounding for a country one thirtieth the size of the United States.

Wabi sabi's influence on Japanese aesthetic values has inspired such arts as the tea ceremony, flower arranging, haiku, garden design, and No theater. It offers an aesthetic ideal that uses the uncompromising touch of mortality to focus the mind on the exquisite transient beauty to be found in all things impermanent. It can be found in the arrangement of a single flower, the expression of profound emotion in three lines of poetry, or in the perception of a mountain landscape in a single rock. Like Zen, its philosophical mentor, it is sublime in its subtlety.

The term *wabi sabi* suggests such qualities as impermanence, humility, asymmetry, and imperfection. These underlying principles are diametrically opposed to those of their Western counterparts, whose values are rooted in a Hellenic worldview that values permanence, grandeur, symmetry, and perfection.

Japanese art, infused with the spirit of wabi sabi, seeks beauty in the truths of the natural world, looking toward nature for its inspiration. It refrains from all forms of intellectual entanglement, self-regard, and affectation in order to discover the unadorned truth of nature. Since nature can be defined by its asymmetry and random imperfections, wabi sabi seeks the purity of natural imperfection.

The Japanese nurturing of this approach to art has created an artistic expression that resonates with a profound philosophical

consistency—a consistency with great historical depth little affected by changing fads and fashions. From the woodblock prints that inspired impressionists like Monet and Van Gogh to the culinary arts that paved the way for nouvelle cuisine, from the many forms of martial arts to Kurosawa's motion picture masterpiece *Seven Samurai*, from the haiku poetry that entranced Gary Snyder to the art of gardening that has captivated the world, Japan's impact on the West has been prodigious—and there is little indication this influence is abating.

The message of wabi sabi, in view of the ever-encroaching materiality of Western society, is as relevant today as it was in thirteenth-century Japan. This ancient approach to life, which breathes new meaning into both the visual and decorative arts, is ambivalent toward modern Western culture, preferring instead a philosophy and design ethos more consistent with our flaws and organic nature. This consistency between philosophy and design principles means that the message of wabi sabi still has relevance for many aspects of modern life.

Note: The terms *East* and *West*, although based on very loose stereotypes, serve to show the broad differences in culture, values, and art between the two areas. As the book is primarily about the Japanese art and philosophy of wabi sabi, the term *East* will generally refer to that region. However, as the cultural history of the whole Far Eastern area is interlinked and much of the Japanese culture is based on the ideas imported from China and Korea, the term will to some extent also include those regions.

HISTORY

THE DEVELOPMENT OF WABI SABI

"To Taoism that which is absolutely still or absolutely perfect is absolutely dead, for without the possibility of growth and change there can be no Tao. In reality there is nothing in the universe which is completely perfect or completely still; it is only in the minds of men that such concepts exist."
 —Alan Watts

THIS QUOTE FROM ALAN WATTS regarding Zen's predecessor, Taoism, captures beautifully the link between religious ideals and wabi sabi's aesthetics. The Taoists in China were, in a very practical and Chinese way, trying to make the most of their lives by living in harmony with nature. It was only through the study of the natural flows of life that they could become one with the Tao, the mystical force that guides all men's lives.

Like a river, the Tao never remains still. This concept became a fundamental principle in the Taoists cosmic view and was to become a hallmark not only of Taoism but of the Zen that was to follow it. This deference for the random and sporadic was to find its voice in many forms of artistic endeavors as the art of the day was driven, as it is today, by the underlying religious beliefs of the artists. Wabi sabi, as a product of the Zen mind, can find its earliest roots in Zen's forerunner, Taoism, and we will explore in these pages its development from its first inklings in China to the cultural icon that it became in Japan.

Although the development of wabi sabi–style art is patchy and hard to pinpoint, one could cite the Song dynasty (960–1279) as the

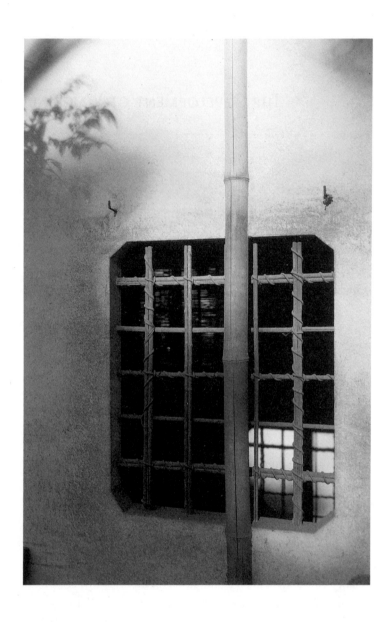

period when art was beginning to show some leanings toward the ideals of wabi sabi, even though they may not have been expressed in such terms. It was at this time that the first *wen-jen hua,* or literati painting, appeared. The literati were amateurs who often disagreed with the styles fashionable at the royal academy and who produced their own distinctive landscapes. The Northern Song practitioners of wen-jen hua preferred less grandiose subjects than did the official painters, often selecting a single tree or a rock with bamboo. This preference for simple subjects remained a characteristic of literati painting. The brevity and simplicity of the work provided ample space for the mental collaboration of the audience, and this was to become a defining feature of later wabi sabi designs.

During the period of the dynasty known as the Southern Song (1127–1279), the emperors' painting academy produced a style of landscape known as the Ma-Hsia school, derived from the two greatest artists of the time, Ma Yüan and Hsia Kuei. Drawing on the expansiveness found in the Northern Song tradition, they created views with much less brushwork. For example, they used mist as a device to suggest landmass and to give the painting a light, ethereal quality. Ma Yüan was often called "one-corner Ma" because he would restrict much of his painting to a single corner of the canvas, leaving the rest blank. This technique enhanced the sensation of open space and suggested infinity, a quality much prized in the Ma-Hsia tradition. The Japanese were to become masters of space, and have throughout their long artistic history stressed the importance of space or nothingness as a juxtaposition to things that presently exist. As the silence between notes in music is vital, so the space provided in art is just as expressive, and wabi sabi has used brevity to magnify the intensity of the expression.

In sharp contrast to the serenity of the work of Ma Yüan and Hsia Kuei stands the brush painting of the Ch'an monks (Ch'an is the Chinese equivalent of Zen and, like Zen, takes its name from the Sanskrit term for meditation, *dhyana*). Followers of this branch of

the Buddhist faith believed in the spontaneity of artistic creation, often producing paintings in a few frenzied minutes. The style, characterized by free and often loosely defined brushwork, was dismissed by official academy painters as the work of "crazy drunkards." The independence of the Zen painting school became an important model in later centuries when more artists became disillusioned with the purely academic styles. Zen monks, because of their profoundly different worldviews, often differed radically from the establishment. This move away from common norms manifested itself in a key aspect of wabi sabi design: that of a love for the unconventional—not simply for the sake of being unconventional but rather because unconventional art stimulates different ways of perceiving art.

The Zen temples in Japan led the way for Japan's arts. It was suggested by a current resident abbot of the Daitokuji temple in Kyoto that one of the first real movements toward an appreciation of physical objects that have a humble and rustic appeal came at a time when Buddhist monks, whose temples were often under funded, had to entertain guests. As they did not own any high-quality art, they had to use what was available to them to produce an aesthetically pleasing effect, and to this end objects of nature such as bamboo and wildflowers were used in place of more ornate artifacts such as Chinese porcelain.

In so doing, they were focusing on the natural, the impermanent, and the humble, and in these simple and often rustic objects they discovered the innate beauty to be found in the exquisite random patterns left by the flow of nature. The small nuances of color, the curve of an opening petal, the crack in a bamboo vase, or the decay of a knot in old timber all came to symbolize *mujo*, which is the Buddhist tenet of impermanence and continuous flux. As the physical manifestations of mujo, these simple objects then became vehicles for aesthetic contemplation. Wabi sabi became the term associated with this quality, and as such mujo forms a defining aspect of wabi sabi

objects. If an object or expression can bring about, within us, a sense of serene melancholy and a spiritual longing, then that object could be said to be wabi sabi. Realizing this, the Zen monks then strove to produce objects and environments that used these characteristics to elevate one's state of mind.

From the Zen monasteries came architecture and aesthetic ideals that were then absorbed into the Japanese way of life, and from this era the profusion of arts was more often than not inspired by the work of a Zen master. One such art is the tea ceremony, which, due to its links with the Zen monk Ikkyu and his school of thought, became a cornerstone of high culture and the expression of beauty in sobriety. With the tea ceremony movement came the art of *ikebana*, flower arranging, and *raku* ceramics. There were several schools of flower arranging, but the one that best represents the wabi sabi sentiments of the tea ceremony is called *nagaire* (literally to throw into). In this school, the arranger ignores principles laid down in other, more regimented schools and instead lets the simplicity of the flowers, in harmony with the visual characteristics of the vase, reflect life's beauty and evanescence. Raku-style pottery was incorporated into the tea ceremony as a reaction to the ornate Chinese utensils adopted by the nobility and emphasized the beauty of rustic imperfection over attempts at perfection. It was during this period that, under the guidance of the tea masters, Japan's artistry moved into a new era with the appreciation of things wabi sabi reaching its zenith.

In this period there was also a more cynical force behind the promotion of wabi sabi art. The wealth that Kyoto had enjoyed as the capital of Japan was greatly diminished by the movement of the capital to Kamakura, which is just outside the modern Tokyo. *Iemoto* was the term used for the founders or inheritors of teachings, secrets, and prized scrolls relating to the arts such as music, dance, No theater, and the tea ceremony, and it was through this medium that teachings were passed down through the generations. This status

then gives the iemoto the right to final arbitration on any points of practice or technique, and as such it was also a valuable source of revenue—not entirely dissimilar from modern-day patents. The sometimes jealous harboring of these treasures and the status they brought has had a great deal of influence on the way arts have developed in Japan. On the one hand, it has maintained a degree of continuity from the original teachings and in some cases preserved the original orthodox practices; on the other hand, it has sometimes become tainted by political and financial considerations, and then strays far from the original spirit intended by the founder. The strict adherence to the ideas given by Sen no Rikyu (see later discussion of the tea ceremony) has led to some aspects of the tea ceremony becoming devoid of any real spiritual union—the fundamental reason for its creation.

It has also been suggested that some of the mystery and intrigue surrounding the ethereal properties of wabi sabi art was intentionally promoted by the iemoto families, whose incomes had been severely diminished by the emergence of Kamakura. Without the funds for the more ornate and gorgeous artifacts, the iemoto families turned their attention to the readily available wabi sabi–style art, and then enhanced its value by shrouding it in mystery. So, the activities of the iemoto families played a considerable role in the promotion of wabi sabi as an art for the refined. And wabi sabi became an art form that offered far greater potential for those willing to uncover beauty in what may have been considered at first glance to be unrefined and ugly.

From this golden era of art the wheels were now set in motion for the transference of ideals of beauty to all aspects of Japanese life. The core philosophy that beauty was to be found in detail was now incorporated into the Japanese mind, where it remained relatively unchallenged until Japan again opened her borders to the West.

The Japanese, consummate artists of observation, were very quick to learn from the West, and within a few decades Japan established

herself as a force to be reckoned with. As she assimilated knowledge of the West, Japan was able to pass new ideas through the filter of its own culture and then take the best that each had to offer. This trend has continued down through the ages, and one of Japan's greatest abilities today is to take a foreign idea, refine it, and then sell it back to the West.

The changes that the West brought to Japan were explosive and altered modes of dress and activities almost beyond recognition. In her desire to catch up with and participate more fully in the hedonism of the West, Japan was prepared to sacrifice much of its culture. There was even, at one point, a narrowly defeated vote on whether the Japanese should keep their own language or switch to English. Fortunately, the language was kept, and it has continued to function as a link between the past and the present. Without it, much of Japan's culture would surely have been lost. With the help of the language and a great personal pride in their cultural heritage, the people of Japan have managed to retain a small nugget of Japanese-ness knitted into the fabric of their words and deeds. They may have been greatly affected by the West, yet they are still first and foremost Japanese, and this can be seen in the different way they still approach work and design.

The Japanese attention to detail and their desire to keep all aspects of design as simple and well balanced as possible are evident even in today's modern designs. The cultural norms that have bound the Japanese through their remarkable history remain entrenched in the national psyche and the way they see themselves, and the objects they design and make are still strongly influenced by their Zen roots. There is an expression in Japanese that says that someone who makes things of poor quality is in fact worse than a thief, because he doesn't make things that will last or provide true satisfaction. A thief at least redistributes the wealth of a society.

The link between modern-day designs and the ancient designs of wabi sabi may seem a little tenuous, but there exists, in the spirit with

WABI SABI IN THE ART OF ZEN

As Zen has been the guiding light for Japanese thought and philosophy for over one thousand years, it has also provided the moral and aesthetic underpinnings for all Japanese arts as they have evolved over the centuries. Through its influence on the nobility and the leading artistic figures through the centuries, it has become ingrained in the Japanese aesthetic sensibility. Therefore, a detailed look at Zen and its development in Japan may throw some further illumination on the aesthetic ideology of wabi sabi.

A Brief History of Zen

Buddhism was founded in northeastern India and was based on the teachings of Siddhartha Gautama, who is now known as the Buddha, or the Enlightened One.

Born into a life of luxury around 563 B.C. he was so struck by the suffering of those living outside the palace that he was spurred to renounce the material world and to seek answers to the mysteries of life. After passing through a stage of extreme asceticism, the Buddha took the middle path, which avoided the pitfalls of both overindulgence and self-denial, and after a great struggle he is said to have attained enlightenment under a bodhi tree.

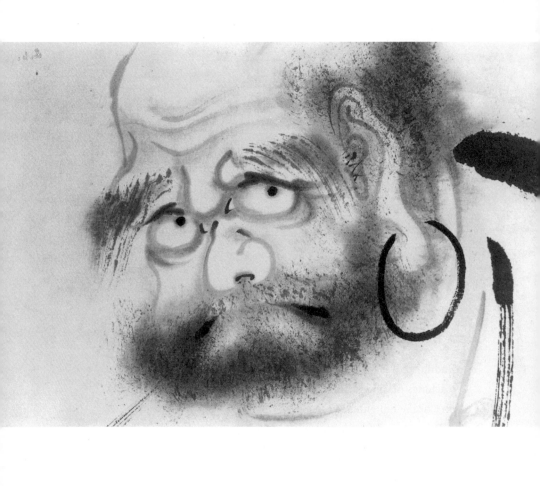

Realizing the nature of reality, he started to preach and formed an ideology based on the Four Noble truths,

- *The Four Noble Truths*
 1. Life is suffering.
 2. All suffering is caused by ignorance of the nature of reality and the resultant craving, attachment, and grasping that stem from such ignorance.
 3. Suffering can be stopped by overcoming ignorance and one's attachment to the material world.
 4. The path that leads away from suffering is the Noble Eightfold Path, which consists of right views, right intention, right speech, right action, right livelihood, right effort, right-mindedness, and right contemplation.

These ideas were passed down from one disciple to another through the ages, but Zen Buddhism was to receive its inspiration from China, where the Buddhist ideas were to undergo radical changes as they passed through a culture that already had strong religious and cultural ideas of its own.

The Taoist movement in China fused with the new ideas coming from India to form the Ch'an school of Buddhism, and this later became known as Zen in Japan. The essential Taoist philosophical and mystical beliefs are to be found in the *Tao-te Ching* (*Classic of the Way and Its Power*), a text dating from around the third century B.C. and attributed to the historical figure Lao-tzu, and also in the *Chuang-tzu*, which was written in the same era and was accredited to a philosopher called Chuang-tzu.

Taoism has been described as "the art of being in the world," and the main thrust of its teaching was opposed to the Confucian ideas of social order. Instead, it stressed that the individual should seek to flow with the watercourse way, the Tao. Lao-tzu described this

mystical concept, which like Zen defies objective analysis, in the following way:

> The Tao is something vague and indefinable
> How indefinable! How Vague!
> Yet in it there is a form.
> How vague, how indefinable
> Yet in it there is a thing.
> How obscure! How deep!
> Yet in it there is a substance.
> The substance is genuine
> And in it sincerity.
> From of old until now
> Its name never departs,
> Whereby it inspects all things.
> How do I know all things in their suchness?
> It is because of this.
>
> —Daisetz Suzuki, *Zen and Japanese Culture*

To be at one with the Tao, one must practice *wu-wei* and refrain from forcing anything to happen that does not happen of its own accord. To be at one with the Tao is to accept that we must yield to a power much greater than ourselves. Through this acceptance of the natural flow of life, and by discarding all learned doctrines and knowledge, a person is able to achieve real unity with the Tao. This harmony brings with it a mystical power known as *Tō*, which enables those who have harnessed it to peer beyond the horizons of everyday perception into a world where there are no mundane distinctions between all the opposing ideas of the dualistic world.

During the time prior to the influx of Buddhist ideas from the Indian subcontinent, the Taoists sought to extend their lives through alchemy, physical regimes, rigorous hygiene, and breathing exercises, but under the influence of Buddhism, Taoist religious groups turned more toward an institutional monasticism. There was also a shift

from the focus on bodily immortality to the spiritual immortality offered by the Buddhists.

The fusion of Taoism with Buddhist ideas is thought to have been inspired by the arrival of the eccentric monk known as the Bodhidharma (referred to as the Daruma in Japan). Bodhidharma was twenty-eighth in the direct line from the first Buddhist disciple, Kasyapa, and when he brought his style of Buddhism to China in 527, it was to start ripples that sent shock waves not just through China but across the seas to Japan as well.

On arrival in China, Bodhidharma was offered an audience with Emperor Wu, who, it seems, was seeking approval from the Indian monk for the devout work he felt he had done. But much to the disappointment of the expectant emperor, the sage, when asked if there was any merit in his building of temples and copying of scriptures, replied, "No merit." Deflated by the abrupt and unexpected reply, the emperor then asked Bodhidharma who was this man who stood before him, to which Bodhidharma said, "I know not, Your Majesty."

From this uncompromising start, Bodhidharma then went on to increase the aura of mystery that surrounded him by spending the next nine years meditating in front of a wall in a cave. Legend has it that he was so determined to succeed in his enlightenment that he cut off his own eyelids when they prevented him from staying awake while meditating. It is also part of folklore that he meditated for so long that his arms and legs fell off, and this is the reason why, in Japan, the Daruma is depicted by red papier-mâché models without legs or arms.

A man called Shang Kwang, who sought the wisdom of Bodhidharma, asked that he might be admitted to study under him. Though he waited in the freezing snow for a week, it was not until he had cut off his own left arm and presented it as a symbol of his determination to learn that Bodhidharma relented and passed on his wisdom to the man who was to become his successor.

The pragmatic and disciplined Chinese thinkers of that time tried to demystify the very ethereal teachings of Indian Buddhism and

to bring in a framework that would allow the great insights to be harnessed in a more practical way. The meeting of the three religions of Buddhism, Confucianism, and Taoism was depicted in the famous picture of the vinegar tasters where Sakyamuni (the name given to the Buddha), Confucius, and Lao-tzu stood around a large vat of vinegar that symbolized life. Confucius found it sour, the Buddha found it bitter, but the Taoist Lao-tzu pronounced it sweet. Taoism seeks to accept things as they are and to find beauty and wonder in the face of the mundane.

Although Zen is in name a Buddhist movement, the impact of Taoism was profound and far-reaching, and the two ideologies are closer in nature than are Zen and other Buddhist teachings. Both eschew learning and formality, and both advocate a return to the natural state of nondualism by transcending our shared view of the world to see reality as it is.

The first seeds of Buddhism were sown in Japan as early as 538 when the king of Korea sent a mission to Japan, which included some Buddhist sutras. It was the Soga family in Japan who actively sought to spread the teachings, but their efforts were hindered by the powerful Mononobe family, who felt that the introduction of a foreign religion would offend the native gods. When the Soga family attained military and political dominance over the Mononobe family in the following century, the dissemination of Buddhism started in earnest. It was Prince Shotoku, second son of the emperor Yomei, whose work in founding monasteries has made his name synonymous with the founding of Buddhism in Japan, although it was to be many years before the Zen Buddhist movement gathered any real momentum.

With the support of the ruling classes, and especially that of the Emperor Shomu, Buddhism flourished in the Nara period (710–794), with monasteries being established in all provinces.

During this time many ideas were being brought from mainland China, often through the Korean peninsula, but despite the free movement of ideas it was not until centuries after Bodhidharma's

arrival that the true core of his teachings found serious adherents in Japan. One of his disciples, Hui-neng (638–713), is considered a key figure in the history of Ch'an, as it was he who wrote the Platform Sutra that delineated all the main tenets of the Ch'an school. Many Chinese Ch'an masters came to Japan to propagate the Ch'an tradition, but they failed to capture a significant audience even though there was much interest in other Buddhist thought at the time.

It was not until the monks Eisai (1141–1215) and Dogen (1200–1253) returned from their pilgrimages to temples in China that Zen started to catch the imagination of the Japanese.

Eisai, who had become increasingly disillusioned with the lack of discipline and growing hypocrisy in his native temples, set sail for China to learn firsthand from the Ch'an masters. After various stays at Tendai monasteries during two separate journeys, Eisai eventually came back to Kyoto and advocated the Chinese style of Zen. This was not well received by the established monks, who had friends in high places, and Eisai was forced to travel to Kamakura, the site of the newly established shogunate, where he received a warm welcome and was made founding abbot of a new monastery called Kenninji. It was from here that he taught a mixture of Zen, Tendai, and esoteric Buddhism that was to become the start of the Rinzai sect.

Dogen founded the Soto sect of Zen Buddhism in 1227 after experiencing enlightenment in the Chinese monastery on Mount Tiantong in 1225. On returning to Japan, he managed to ruffle the feathers of the establishment monks at the Tendai center with his uncompromising approach to the teaching of Zen and hard-line avocation of the principles of *zazen* (seated meditation). Disapproving of the political tensions in the capital of Kyoto, he moved his headquarters to Echizen province, now Fukui, and established Daibutsuji which later became known as Eiheiji. This has since become the center for Soto Zen.

Although Dogen saw no difference between the various schools of Zen, there were others who classified them according to the methods

of training. The Rinzai sect accepted the importance of zazen but also encouraged acolytes to exhaust their cognitive activities by concentrating on a *koan*—a seemingly irresolvable riddle with no logical answers. The idea was for the koan to help in exhausting the intellectual process so that a clearer view of reality would reveal itself.

So What Is Zen?

Ch'an, or Zen, as it is more commonly known in the West, is the peculiarly Chinese way of achieving the Buddhist goal of breaking down all learned ideas of the world so as to see the world as it is—that is, with a mind free from attachments or judgments. This state is reached through rigorous mental effort, and the path is paved by the achievement of *mushin* (literally "no heart"), where one is freed from mundane attachments or desires. When an acolyte has succeeded in calming his thoughts and emotions, he is then ready to perceive the world without any preconceived notions. This is the prerequisite for the state of enlightenment known as *satori*—the goal to which all Buddhists aspire. Indeed, it is a state of mind that mystics, sages, and sorcerers have channeled great efforts to achieve. Zen differs from other schools of Buddhism in that it believes that this awareness does not come gradually, but as a flash of insight, so it puts no store in theorizing or trying to explain the unexplainable. It focuses all its energies on bringing about this monumental shift in awareness, the shift that will free the acolyte from the bonds of a world that is too real. Because of this Zen monks have been renowned for their eccentric behavior and cryptic answers to questions. They believe that our reason is the greatest source of misunderstanding because it actually hinders a student's deeper comprehension of the world that exists beyond words. Humans are slaves to words and the reason they produce.

Breaking the bonds of dualism has been an ever-present theme in many religions and philosophies. From the moment of birth, we are constantly given a dualistic view of the world from our parents, and

this is reinforced by all those we come into contact with until it becomes so internalized that we forget that it was even learned. We are taught that we are separate from the outside world, and objects that are not part of our body are separate from us. Zen masters say that this is pure illusion and that we are in fact everything we perceive. In modern psychological terms, a child is said to become egocentric when he has learned to distinguish himself from the world he perceives. It is just this *learned* idea that we are separate from our environment that Zen says we need to *unlearn*. By loosening the concept of self, or in Freudian terms the ego, the world takes on a new dimension where true art and creativity can begin.

A professor of philosophy may start his first lecture by talking about the realness of a chair and all the assumptions that have been made to arrive at the idea that the chair is a solid item, out there and real. This is something that most in the West would think a little crazy to even contemplate. Of course the chair is a solid Newtonian object that exists in its own right. To deny this would mean that our deterministic view of the world was wrong and that the ontological precepts that are so ingrained in our thoughts would have to be reassessed. Through education and devotion to science we have left behind the ideas that the world may hold a little more magic than we suspect. The following poem by Edgar Alan Poe encapsulates the slavish demands of a scientific worldview.

> Science! true daughter of Old Time thou art!
> Who alterest all things with thy peering eyes.
> Why preyest thou thus upon the poet's heart,
> Vulture, whose wings are dull realities

Zen would say that in adopting, too completely, the scientific view of reality we have closed the door on a more holistic view of life and are limiting ourselves to a rather mundane view of something altogether extraordinary. There is a little irony that the science that brought us the Newtonian view of the world has now found, through the study

of atomic and astral physics, that in fact the world is far from Newtonian. A solid particle has yet to be found, and instead scientists are coming to the realization that matter as we know it may not actually exist but is rather a movement of energy. Time, space, and mass are all relative concepts, and the view that the world in real, solid, and out there has become untenable to the scientific community, too. Despite these discoveries there still seems a dogged determination to hold on to the old views of reality, which tend to provide a rather comfortable haven for the frail intellect that feels the need to hold on to its view of the world.

Zen maintains that our dualistic view of life means that whatever we perceive goes through our mental filtering systems before being cognitively understood. We use mental boxes for all aspects of our daily lives so we can make sense of our world and interact with others. With the development of language, though, this cognitive grasp of reality means that everything we perceive is subject to these mental processes, and so from early childhood we lose the ability to directly perceive the world. This is the point where dualism starts.

Nevertheless, in our more intuitive side, maybe we can still sense the lost world we had as infants, and it may well be this more intuitive feel that wabi sabi art helps to engender. It can put us back in touch with our nondualistic perception, where the need for words becomes obsolete and art can touch our innermost feelings. Starting from the Buddhist premise that newborn babies are in an enlightened state, it follows that their perceptions of the world would be radically different from those of an adult who has learned a completely new way of understanding reality. The emotions of childhood and the memories that are stored in the deepest recesses of the mind can be touched by truths we may be consciously unaware of, and it may be this unconscious affinity with things wabi sabi that trigger the emotional responses we feel toward them. The Zen monks, with their insights into reality, saw this link between art and the state of an enlightened infant, and have used art as a vehicle to rekindle these connections.

Returning then to the question of "What is Zen?" The answers given by Zen masters illustrate the illogical and nonintellectual nature of the question. Some of the more famous answers are:

"Zen"
"The clouds in the sky and the water in the jug"
"I do not understand"
"The silk fan gives me enough of a cooling breeze"

Zen was often studied in a semimonastic environment where austerity and intense meditation, combined with hard physical work, were fundamental tenets for the improvement of one's spirit. Despite the sparse nature of the temples, they were great fountains for artistic endeavors, and much of the art was done by Zen monks. These endeavors were not limited to brush painting, but encompassed calligraphy, the martial arts, gardening, architecture, and even the drinking of tea.

The dedicated monks, in a spirit of quiet and resolute determination, sought to find artistic expression in all they did, and this art was then the fruit from their very focused minds. The renowned monk Hakuin had a favorite expression that meditation in the midst of activity was far better than meditation in stillness. For the Zen monks, everything they undertook became a spiritual task in which they had to immerse themselves totally, and in doing so they absorbed themselves in the activity rather than in their ego's understanding of the activity.

Zen's direct approach and its determination to avoid explanations gave it a more direct vision of nature rather than a verbal interpretation of it. In Zen philosophy the mind should be a window, rather than a mirror, so that the world is seen directly and not through the filters of the intellect.

The Zen view of the world, complex and alien as it is to the West, may be characterized by the following beliefs:

- We are living under the illusion that the world is dualistic.
- This illusion causes people to cling to the idea of themselves and the material world, which then leads to suffering.
- Life is evanescent and fleeting, but overcoming the fear of death is vital for the fulfillment of life.
- Through meditation and great effort, it is possible to break the chains of our perceptions and to realize the true nature of our reality. In so doing, it releases us from the suffering that comes from misunderstanding.

These ideas on life had a dominant effect on the development of art, not just in the temples but also in the societies of Japan and China, and the subject matter of Zen art is a physical manifestation of their beliefs. The paintings tended to be based on scenes from the rural environment, such as birds, trees, rocks, and mountains, and were presented merely as images that encapsulated their essence rather than exact interpretations of their nature. The work was usually done in moments of inspiration and often in broad and sweeping brush strokes, where the vision held by the artist was committed directly to paper with a minimum of deliberation or contemplation. It focused more on the direct experience of perception rather than ideas relating to those experiences. These works, more often than not, had many elements that could be defined as wabi sabi, and perhaps one could define the four tenets of wabi sabi as follows:

- Everything in the universe is in flux, coming from or returning to nothing.
- Wabi sabi art is able to embody and suggest this essential truism of impermanence.
- Experiencing wabi sabi expressions can engender a peaceful contemplation of the transience of all things.
- By appreciating this transience a new and more holistic perspective can be brought to bear on our lives.

As Zen became more established throughout Japan during the Muromachi period (1333–1568), its influence on politicians and artists grew tenaciously, and the tenets of its philosophy, so closely bound to those of wabi sabi, found representation in the arts of painting, No drama, flower arranging, and of course the tea ceremony.

The political turmoil of the Muromachi period, whose upheaval was no doubt a considerable factor in the spawning of so many creative ideas, was followed by the Tokugawa shogunate (1603–1867). After Tokugawa Ieyasu had succeeded in bringing together all the separate warring factions under one ruling government, the complexion of life in Japan changed dramatically. The Christian influence, which had managed to gain an incredible following in just a few decades, was seen as a direct threat to life in feudal Japan, and so the shogunate decided to close Japan's boarders to all but the most minimal of foreign exchange. This policy was known as *sakoku* (literally "closed country"). Trade was limited to Nagasaki, and only the Dutch, Koreans, and Chinese were tolerated. Any attempts to preach Christian ideals were met with the death penalty. The Japanese had entered their most settled period and it was a time of consolidation of the arts and culture that had been forged during the more volatile Muromachi period.

It was within this sheltered environment that the government's support of Buddhism, along with that given by the more affluent ruling classes, provided a fertile environment for the furtherance of spiritual learning. It was also a time of creativity for the Zen monks, who pioneered much of the art created during the Edo period (1603–1867). However, the true spirit of Zen was very often compromised by the balance of power between those with the wealth and those providing the spiritual guidance. This was not at all dissimilar to the divisions between the church and the ruling classes in Europe during the same period. Yet despite this clash of interests between the different sects vying for political and economic favor, the religious and artistic focus still remained strong, and there was a maturation and refinement of earlier artistic ideas.

The foundations for wabi sabi art forms, like the tea ceremony and flower arranging, were laid in the Muromachi period by exponents such as Sen no Rikyu (1522–1591), and it was these early innovations that provided the artistic momentum for the ensuing centuries. As time passed, the arts that had been inspired mainly for the benefit of the ruling elite slowly found their way into the lives of the lower classes. In so doing, the ideals of Zen and its artistic companion, wabi sabi, found greater influence and support across a broad spectrum of Japanese society. After the passing of Sen no Rikyu, the baton was taken up by other cultural icons such as Hakuin (1686–1769) and Sengai (1751–1837), whose enlightened views of the world pervaded all aspects of their voluminous works and continued to stimulate the artistic movement in Japan—a movement that was becoming ripe for an overseas audience.

Japan eventually reopened her borders. And after more than 250 years of isolation, the world was quick to see the value and depth of Japan's unique artistry, and it was not long before European impressionists like Monet were collecting large quantities of woodblock prints and other treasures of Japanese craftsmanship. But, because of the large gap that existed between the philosophical views of the world, the ideas behind wabi sabi were not as quickly seized upon, as were the more immediately impressive artworks such as the silk kimonos, elaborate screens, and swords. The West's appreciation of things wabi sabi took more time to develop as a deeper understanding of its meaning and significance began to slowly seep into the Western consciousness.

Over the last century, in the advent of Japan's intense integration with the West, there has been a vast sharing of ideas and philosophies, with the West being as stimulated by Zen as the Japanese have been influenced by the Western lifestyle. However, the changing aspirations of people in the modern world have taken their toll on the spirit of Zen, and especially in Japan, its relevance and ability to influence the lives of the Japanese has been steadily subsiding over the last

THE TEA CEREMONY

"Tea has become more than an idealisation of the form of drinking; it is a religion of the art of life. The beverage grew to be an excuse for the worship of purity and refinement, a sacred function at which the host and guest joined to produce for that occasion the utmost beatitude of the mundane." —Okakura Tenshin, *The Book of Tea*

AS THE GUIDING FORCE behind wabi sabi aesthetics, a look at the tea ceremony will throw light on the reasons for its development and the figures who formed the ideas that remain to this day.

The tearoom is to wabi sabi what the church is to Christianity. Both enshrine their ideals and philosophies and cultivate an atmosphere appropriate for the intended religious goals. In a church there is a sense of reverence for the deity of God and his son Jesus Christ; within the vaulted ceilings and the magnificent stained-glass images there is a glorification of the greatness and omnipotence of God. In the tearoom there is a sober veneration for unadorned rusticity, for the greatness to be found in the most restrained expression of the humble and simple. The idea of venues being switched invites some interesting imagery.

The tea ceremony, which is usually held in a secluded and intimate tearoom, has been one of the focal points for advocates of wabi sabi. It was through this semireligious ritual that the tea masters, well versed in the philosophy of Zen, gave full voice to their love of art rich in wabi sabi expression. They developed their shrines in the same

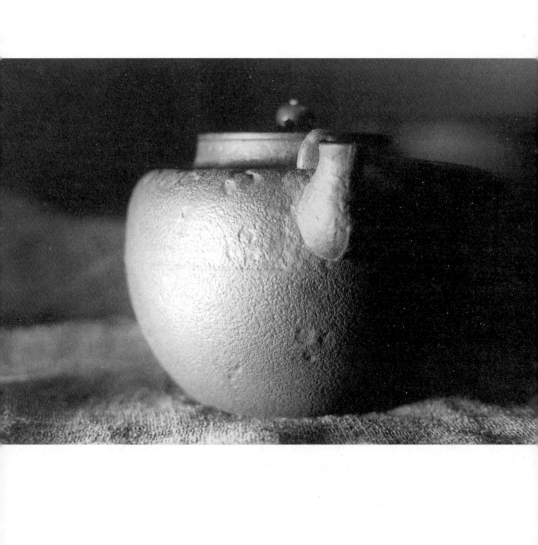

way church clergy have created ecclesiastic designs. Both are guided by their spiritual beliefs.

The tea ceremony, where the art and philosophy of wabi sabi cemented its foundations, can trace its roots back to twelfth-century China with the drinking of tea by Zen monks who gathered before the image of Bodhidharma and drank the beverage as a part of the ritual. Like its guiding philosophy, Zen, the appreciation of tea found its way to Japan through the Zen monks. But unlike China, whose refined culture was decimated in the thirteenth century by the Mongol invasion, Japan was able to continue the refinement of tea drinking until, under the patronage of the shogun Ashikaga Yoshimasa, it became an independent secular ceremony.

The nobility in Japan took great interest in tea and it was not too long before it had established itself as a cultured beverage to be enjoyed in a refined atmosphere. Through the Kamakura period (1185–1333), the formalization of the tea ceremony began to emerge, and certain rules and etiquette surrounding its consumption were observed. The tea ceremony was promoted along with the teachings of Zen and the two cultures developed hand in hand throughout Japan. With the Zen belief of greatness in the smallest things, immense emphasis was put on all the small details of life, and with the attention to detail came care, and with the care came the meditative qualities of the tea ceremony. The intense concentration needed to perform a tea ceremony was both a discipline and a purification, for through the focusing of the mind on the microcosm of the tearoom, the rest of life's concerns would melt away.

In the troubled Muromachi period, when the warring clans were all seeking to establish greater strength in their power bases, the samurai and warrior classes found great solace in the sublime world of tea. In entering the small room, they were existentially removed from their roles and responsibilities, from the hardships of combat, and taken to a place of harmony and peace where the world might make sense again. As with the development of many great artistic

achievements through history, it was the upheaval of the Muromachi period that brought the Herculean leap in the arts of Japan. Ironically, it was under the greatest stress that the best art was produced, and it was during this time that the foundations for the tea ceremony, along with many other peculiarly Japanese art forms, were laid.

The Zen monk Ikkyu (1394–1481), whose life straddled an era of great political instability, was a pivotal figure both in Zen and in the development of a wabi sabi–style tea ceremony.

Ikkyu was thought to be the illegitimate child of the Emperor Go-Matsu and a lady of the Kyoto court, but after his birth his political potential made him many enemies, and he and his mother were thrown out of the palace. Following this, Ikkyu entered the Zen temple Ankokuji, where he received an extensive education in the Japanese and Chinese arts and classics. From an early age it was more than evident that he possessed an incredibly sharp wit, and tales of his antics still survive today. One of the abbots of the temple had a great fondness for a sweet snack, which he jealously kept in his quarters, and he admonished the young acolytes that it was poisonous to children. Unfortunately for the abbot, the young Ikkyu was not taken in by this, and having shared the bounty with his friends deliberately broke a piece of pottery in the abbot's quarters. When the abbot returned from his duties the young Ikkyu explained that he had accidentally broken one the abbot's pots, and that he had tried to make amends by committing suicide through the consumption of the poisonous sweets. Having felt no ill effect after the first piece he felt it necessary to make absolutely sure by eating them all. His lies and hypocrisy exposed, the abbot was in no position to make an example of young Ikkyu.

Ikkyu's impish nature was not even tempered when invited to an audience with the Shogun Yoshimitsu, and when asked if he could catch a tiger, Ikkyu said he could. The shogun then wryly asked Ikkyu to use a rope he then supplied to catch the tiger painted on one of the screens. Without a moment's hesitation the young monk sprang into

position in front of the screen and asked the shogun to chase the tiger out.

Despite his obvious humor there was, beneath the surface, a very motivated and sincere student of Zen who had an earnest desire to achieve true wisdom in his lifetime. He soon became disillusioned with the corruption prevalent in temple life, and the following poem, which he wrote when leaving the temple, catches his mood at that time.

> Feeling such shame, I can stay silent no more
> Zen teachings are being replaced by victorious demonic
> forces.
> The monks should be lecturing on Zen,
> But they just brag about their family history

He chose to further his studies with a reclusive monk called Ken'o, who lived in the hills around Kyoto and whose teachings resonated with the sincerity and consistency sought by Ikkyu. Ikkyu faithfully served Ken'o, whom he loved deeply, and was so distraught by his master's death four years later that he tried to drown himself in Lake Biwa. His attempt was foiled by his mother's servant, who had been sent to keep an eye on the despondent young monk. After a few years studying under the strict regime of another master called Kaso, he was awarded a much prized *inka*—a certificate from his master confirming his enlightenment. Ikkyu threw the inka back at his master, and in so doing cut himself off from a possibly lucrative life as an abbot in another monastery. Ikkyu put no store in paper enlightenment or the credit it could confer—his sights were set on nothing less than a complete personal freedom. Following a later rupture in their strained relationship, Ikkyu started his journey as an itinerant monk roaming the streets of Kyoto and never really settled for the remaining fifty-five years of his life.

His rather eccentric behavior and quick wit endeared him to the wealthier inhabitants of the city and allowed him to enjoy some of

the more sensual delights of Kyoto, including those of the "Floating world." Ikkyu was quite unusual in his open use of and obvious pleasure gained from time spent with the female sex, and instead of denying the fact he advocated it as a healthy activity for men and monks alike.

In his love of life and disdain for formality and rules, Ikkyu promoted the tea ceremony and even went so far as to suggest that it could be more productive than hours spent in solitary meditation. With his Zen sense of restraint he pushed the focus of the tea ceremony away from ostentatious shows of wealth and toward the spiritual communion of two or more people who, in a state of calm and controlled abandon, could meditate on the beauty and transience of life. Although Sen no Rikyu is often credited with being the father of the tea ceremony, many of the original ideas and the adoption of rustic utensils was at the instigation of Ikkyu. His influence on the spirit of tea was far-reaching and arguably as important as the later contribution made by Sen no Rikyu.

It was one of Ikkyu's students, Murata Shuko (1422–1502), who was to become tea master to the Shogun Yoshimasa. In keeping with his master's dictums, Shuko had urged the aristocracy to refrain from opulence and instead to focus on the personal nature of the interaction between one human and another. It was at this time that the first four-and-a-half-tatami mat tearoom (each mat being approximately six feet by three feet) was made within the Silver Pavillion (Ginkakuji).

Ikkyu's determination to maintain the pure spirit of Zen had a great influence on the many aspects of the art of his time, and it is fitting that a hanging scroll of his calligraphy was placed within the first tearoom designed by his disciple. This then set in motion the Japanese custom of having a hanging scroll in the tearoom, from where it then became an important decorative feature to be included in many residences throughout the land—one that is still found in many houses today.

The Zen movement developed hand in hand with the arts it was inspiring. And it was Takeno Joo who, having received instruction in the ways of tea from Shuko and Jotei (the reputed son of Ikkyu), then transmitted his teachings to Sen no Rikyu.

Sen no Rikyu's eye for aesthetic balance and his predilection for the simple and unadorned helped to change the focus of the tea ceremony from a display of culture and wealth to a communion of kindred spirits seeking purity and truth. Although he met an untimely death with his master's order for ritual suicide, his impact on the arts and the way that Zen was used in the arts was a monumental achievement that has inspired the Japanese throughout the ensuing centuries.

It was the influence of Zen that had promoted the ideas of mute colors, simple utensils, and economy of expression, but it was Rikyu who managed to crystallize these ideas into an aesthetic whole and to blend the garden, the tearoom, the food, the tea, and the conversation into the refined art form it is today. The tearoom design was an extension of Zen monastery design principles, with an emphasis being put on simplicity and sobriety. The small fragile hut is a temporary refuge for the traveler, as the body is but a temporary refuge for the soul.

With Rikyu came a more defined pattern for the tea ceremony, and certain principles were established according to the directives of the tea master of the day. Many of the ideas that were laid down five hundred years ago have survived almost unchanged right through to this day.

The Experience of the Tea Ceremony

The tea ceremony is a multilayered experience in which a participant is able to enjoy the tastes of carefully prepared foods and beverages in a state of awareness heightened by the nurturing environment of the tearoom. The experience of the tea ceremony is then based in

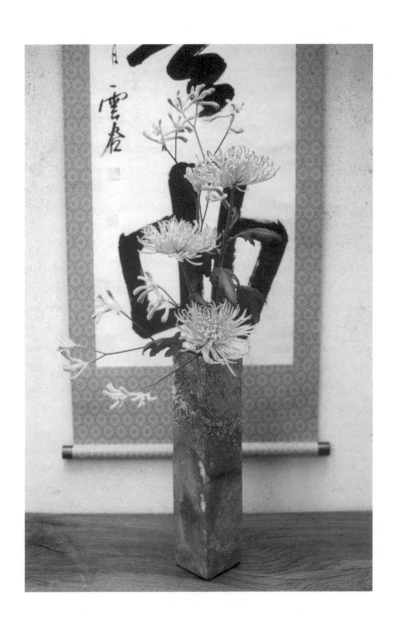

part on the aesthetic pleasure aroused by the wabi sabi elements of the tearoom design.

Much has been written about the ceremony, with opinions ranging from rapture to an unequaled ennui. The idealized image of a tea ceremony, which may be a distant relative of the modern equivalent, might run along the following lines.

The master of tea would decide on a date for a tea ceremony and then, with the utmost care, select and invite a small group of participants whose character and positions would be suitably balanced. The date may well coincide with an anticipated natural event such as the blossoming of the cherry trees or the changing colors of the autumn leaves. Depending on the season and any current moods, he would then make a theme for the *machia*, or meeting, so that the event is held together by the glue of consistency.

Once all the preparations have been made, the tea master will signal his readiness to the guests by wetting the stepping-stones near the entrance. On arrival, the visitors will wait in a special room called the *machiaishitsu* and will have a chance to get acquainted and confirm the order in which they will each participate. After the tearoom has been carefully cleaned and all the artistic accents put in place, the tea master will then ask the visitors to pass through the garden to the small tearoom.

While walking over the uneven stepping-stones, which have been designed to guide the visitor through the special features of the garden, the participants should be mentally preparing themselves—a preparation to leave themselves and their petty worlds behind to become one with the communion of tea. The tenacious moss clinging to the sides of the damp rocks, which seem so alive with a myriad of subtle hues, the flow of spring water through rustic bamboo into an antique water bowl, the livid autumn colors of the maple leaves—all invite the spirit to abandon itself to the unrivaled beauty and natural imperfection of the fleeting world. The mind prepared, the visitors then pass through the tiny door that symbolizes a total

equality of status and are met by the aroma of the purest incense as they enter into the womb of the tearoom.

Within the *tokonoma*, or alcove, a perfectly balanced and austerely simple flower arrangement lies beneath a *kakejiku*, or hanging scroll— the flowers reflecting the sentiments of the kakejiku. The sentiments in the scroll in turn will be a literary allusion to the theme of the meeting and the guests will savor the meaning of the script and the pattern that the bold black ink makes against the pale background.

Once all the preparations are in place, the tea master can now use his consummate skills to properly welcome the guests and to serve them food and beverages. Every movement from the master is pure poetry as his concentration brings a fluidity and precision to every action. The years of practice now bring the moves, rehearsed so many times, into the realm of art in its purest form, for it is art without art, art without thought, art as a pure connection with the ultimate reality. The perfect clarity of mind and seamless movements of the master evoke a hypnotic effect in the participants, who then can become one with the mind and spirit of the tea master. Here is the heaven and oblivion sought on earth—the jealous intellect that guards our every thought and action, relinquishes its vicelike grip, and allows us to taste the reality of the present, the infinite, the wondrous, and awesome world we all left in our early childhood.

SEN NO RIKYU—MASTER OF MASTERS

Sen no Rikyu was born in Sakai into the family of a fish wholesaler, although it is said that his grandfather was a retainer for the Muromachi shogunate. As well as studying the ceremony, he also spent many years as a Zen monk in the temple of Daitokuji in Kyoto, and it was this training that was to inspire his creative work through the rest of his long life.

When Rikyu took up his position as tea master to Toyotomi Hideyoshi, he took the ceremony to a new level of refinement. At the time he started serving his master, the tea ceremony was a pastime for the

wealthy elite, which was often a pretext for those of wealth and power to show to their peers the ornate and beautifully crafted tea utensils they had imported from China. By the time of his death he had realigned the tea ceremony as a pure and simple ceremony to be enjoyed by one and all.

To Sen no Rikyu this preoccupation with the gorgeous Chinese works of art ran contrary to the true spirit of tea. He felt that by focusing on the material world, the attendants and host were completely missing the latent spirituality of the ceremony, the essence of which lay in its appreciation of the modest and mundane.

The story has it that one day as he was walking through town, Sen no Rikyu saw a rustic roof tile whose rough texture and subtle nuance of color caught his imagination. He asked the roof tile maker, Chojiro, to produce, in the same fashion, some utensils for use in his tea ceremony. This adoption of rustic utensils had also been advocated by Ikkyu, but with Rikyu's influence in matters of taste, the relatively small shift in utensils heralded a monumental shift in the philosophy of tea. Instead of the mind being drawn toward materiality, it was being encouraged away from it, toward introspection and a contemplation of the evanescence of life. From this time on, Sen no Rikyu sought to further align the philosophy of tea with that of Zen, and in so doing he helped steer the tea ceremony into a more spiritual realm. He took the principles for wabi sabi and made them an indispensable part of the tea ceremony. With that, the employment of wabi sabi aesthetic principles became de rigueur in the world of tea. Sen no Rikyu had succeeded in bringing the ideals of tea and wabi sabi under the same roof and had further highlighted the value that could be found in the simple and natural.

His architectural ideas for the layout of the tearoom were inspired by the simple and restrained designs of Zen temples. At every turn he aimed to par away everything that was not strictly necessary to leave only the most austere and yet sublimely refined environment in which to enjoy the sharing of tea.

It was at this time that the ideas of wabi and sabi were starting to take on much more positive connotations, and the solitude and austerity of the hermit's life became synonymous with freedom from worldly ties. Sen no Rikyu brought these feelings of wabi sabi into the design of his tearooms so that those attending might feel the touch of mortality, the flow of life to death, and the serene desolation that comes from this understanding.

Although cleanliness and attention to detail were vital tenets of the tea ceremony, Sen no Rikyu did not wish to sterilize the environment. There is a story about how he asked his son to clean the area surrounding the tearoom. This took most of the day, and afterward his son protested that the stepping-stones had been scrubbed three times, the floor had been polished, and every twig and leaf had been picked up. Rikyu then went over to a maple tree that was crimson with the autumn leaf and shook it so that some of its beautiful leaves fell randomly to the floor. He let the artistry of nature put the finishing touches to the earnest endeavors of his son, and in so doing struck a perfect balance between the two. Wabi sabi is not solely the work done by nature, nor is it solely the work done by man. It is a symbiosis of the two. This story is often quoted by the Japanese as being the best way to describe the spirit of wabi sabi. Wabi sabi may abound in nature, but only by catching its subtlest moods and framing them can man bring himself closer to the secrets that nature whispers.

During his seventy years of life, Sen no Rikyu established himself as the nation's authority on matters of taste and aesthetics, and it is no exaggeration to say that he is the founder of what has become the Japanese aesthetic ideal, for he played a defining role in the advancement of the tea-based wabi sabi ideals.

Unfortunately his influence was not restricted to the world of tea, and his position and sway in the political arena caused him to become embroiled in the turmoil of the day. There are several versions as to why his master, Hideyoshi, ordered him to commit suicide, including alleged racketeering of tea utensils, the placing of his

own statue in the shogun's garden, his refusal to allow his daughter to marry the shogun's son. But the most likely reason was that he was accused by a political enemy of plotting to overthrow the shogun—grounds enough to seal his fate.

It was considered an honor for those of samurai rank or higher to be allowed to kill oneself rather than be put to the sword. To take one's own life was seen as far more honorable, as one could show one's indifference to death—one of the gauntlets thrown down by Zen. The term *harakiri* (literally "abdomen cut") was significant because the stomach was considered the area where the soul resides, and was therefore the center of a person's will. Being of high rank, Rikyu was afforded this right, and in keeping with his beliefs and love of tea, Sen no Rikyu held a final tea ceremony for his closest friends. Throughout the poignant ceremony his concentration and attention to detail were exemplary. After the ceremony, once the tea had been consumed, Rikyu gave his beloved tea utensils to his friends, all save his own; this he crushed in his hands, saying, "No more will this cup, tainted with the lips of misfortune, be used by another."

Those attending fought back their tears before being asked to leave, while his chosen second stayed behind to help his master onward. Sen no Rikyu then removed his outer kimono to reveal the pure white death robe that had been carefully hidden underneath, and then with his last death poem he met his destiny in the same resolute way that he had led his life.

> "Welcome to thee,
> O sword of eternity,
> Through Buddha
> And through Dharuma alike
> Thou hast cleft thy way."
> —Translated by Okakura Tenshin

CULTURE

A Leap of Faith

"Translation is treason." —Part of an Italian proverb

FINDING AN ENGLISH EQUIVALENT for a term such as wabi sabi is more challenging than one might at first believe. This chapter will explore the etymology of the two words to show the complexity and ambiguity that they have come to represent, and by looking at their passage and usage through history, a broader picture should emerge of the feelings the words invoke in the hearts of the Japanese.

Like a great many other words that are descriptive of emotions and ideologies, the words *wabi* and *sabi* have traveled through a millennium of cultural change, and in so doing have collected a vast amount of cultural baggage. As usage and intended meanings change, the complexion and depth of words can increase exponentially. Some of the words adopted by recent generations, such as cool, wicked, and fat, have all taken on positive new connotations and have therefore changed the meanings they suggest. Words are like living organisms, they evolve to match the expressive requirements of those using a language. As the words *wabi* and *sabi* have evolved over such an extended period, they have been used to express a vast range of ideas and emotions, and so their meanings are more open to personal interpretation than almost any other word in the Japanese vocabulary.

One of the main reasons why the Japanese are rarely willing to voice a definitive opinion on wabi sabi is because of the incredible mélange of feelings the term implies. The Japanese love ambiguity,

and in literature the writer will aim to maximize the potential meaning of his prose by deliberately leaving out subjects and objects, thus increasing the scope of interpretation. This is very well illustrated by three-line haiku poems, which open an idea for the reader to expand on as they wish. Instead of trying to define a term, the Japanese prefer to maintain the vagueness that it represents. The orientations of those in the East and West show a clear divide here. While Asians tend to prefer intuition and emotion-based decision making, there is in the West an underlying preference for clarity and logic that goes hand in hand with the deference for science. In negotiations between the two, such differences often lead to misunderstandings.

Zen Buddhists have always been wary of the pitfalls of language and consider it the greatest obstacle to real understanding. The phrase *Furyu monji* (literally "not standing on words or letters") denotes the Zen concept that no deep understanding can be transferred by the spoken word: "Those who do not know speak, those who know speak not." Trying to explain the path to enlightenment is as futile as trying to catch the reflection of the moon in a pond, and there is a tradition in Zen of maintaining ambiguity so that the mind does not get trapped focusing on the wrong thing.

However, as humans who share the same range of emotions and who face the riddles of life, there lies within us a commonality of feelings beyond any culturally biased cognitive grasp of reality. It is to these intuitive feelings to which wabi sabi is better suited, and by avoiding too much intellectual analysis, even those with little exposure to the arts of Japan can find inspiration in the purity of wabi sabi and the ideals it represents. Although an understanding of the term within a purely Japanese framework may be unattainable, the beauty of the philosophy it enshrines is there for all to enjoy.

Our appreciation of wabi sabi may be enhanced by looking at the ways in which the two words have evolved over the centuries.

The word *wabi* 侘 comes from the verb *wabu*, which means to languish, and the adjective *wabishii*, which was used to describe

sentiments of loneliness, forlornness, and wretchedness. However, these very negative connotations were used in a much more positive way by the literati of the Kamakura and Muromachi periods to express a life that was liberated from the material world. A life of poverty was the Zen ideal for a monk seeking the ultimate truth of reality, and so from these negative images came the poetic ideal of a man who has transcended the need for the comforts of the physical world and has managed to find peace and harmony in the simplest of lives.

One of the first references to the word *sabi* 寂 in a literary sense was made by the poet Fujiwara No Toshinari, who used it to convey a sense of desolation, employing such visual images as reeds that had been withered by frost. This pattern of use increased, as did the spirit of utter loneliness and finality implied by the term, and it went hand in hand with the Buddhist view on the existential transience of life known as mujo. The concept of mujo, taken from the Sanskrit *anitya* meaning transience or mutability, forms the axis around which Zen philosophy revolves, and it has long been integrated with the philosophies of the Japanese artistic community. The idea that nothing remains unchanged and that all sentient beings must die has always added the touch of finality and brings perspective to all actions of mankind. Death's touch is seen as the best possible source of wisdom, for nothing can seem more important than anything else when the idea of not existing is brought into the equation. There is within the Japanese a fascination with death, and unlike the West, which tends to shy away from what might be considered morbid deliberations, the Japanese seek to harness the emotive effect of death to add force and power to their actions. With this force also comes a sense of inconsolable desolation, and it is this feeling to which the term *sabi* is often applied.

With the great haiku poet Matsuo Basho (1644–1684), the term *sabi* was employed as an aesthetic juxtaposition to the essence of life and threw into focus the impermanence of our situation and the folly

of trying to deny this unmovable truth. The beauty of Basho's prose, however, took the negative aspects of old age, loneliness, and death and imbued them with a serene sense of beauty.

Melancholy, an emotion nurtured in the Zen world, was used as a whetstone on which to sharpen spiritual awareness; this was not a self-indulgent form of self-pity but rather a sadness tinged with an intangible longing. It was in the face of the most undesirable of human conditions that real beauty could be found and the chords of the unconscious spirit, so aware of our fragility, can be touched very deeply when our worlds are put into context. Some, like the great Zen academic Daisetz Suzuki, suggest that it is a longing for the world we left as children, the world of the here and now, undefined by language or values, just a pure experience of reality. It is a world that, at some point in everyone's childhood, is surrendered for the world of logic—a world that is constantly being analyzed and explained by intellectual machinations, a world that no is longer in direct contact with the present.

So the terms *wabi* and *sabi* both find their roots in the nihilist Zen cosmic view, and between them convey the interplay between youth and old age, beauty and ugliness, life and death—the rhythms of nature. If one wished to be more specific, wabi tends to be more associated with lifestyle, whereas sabi is often used to describe the more physical characteristics of objects that display a sense of the impermanent and whose forms are astringent and unpretentious. This being said, the words have inherited so many connotations and interpretations that for all intents and purposes the two can be used, at least outside academic circles, interchangeably and together. The meaning implied by any of the three combinations represents something so vast and intangible that further scholastic classification runs against the spirit of Zen.

The wabi sabi aesthetic ideals, then, which have been employed not just in the tea ceremony but in nearly every form of Japanese artistic expression, have come to represent a bridge between the trappings

of the material world and the pull we all feel, to a greater or lesser extent, to a life of austerity and simplicity. If the spirit is ready and willing, then a three-line haiku poem set in the tokonoma (the traditional alcove), complemented by a simple yet perfectly balanced flower arrangement, should be sufficient to push the viewer's awareness to new heights and to help him or her find a serene balance between the joy of life and the inevitability of the waiting void.

As with all art forms, it is the mental awareness of the audience that will dictate the outcome of the perception. For the Japanese, who have a long tradition of spiritual training and an appreciation for sublime simplicity, the beauty captured in the opening of a single bud or the patina of an antique bamboo vase will be far more evocative than an expression of wealth, power, or opulence.

So without wishing to compromise the scope of the term *wabi sabi*, the following represents a personal interpretation that can only serve as a starting point for the potential implied.

> Wabi sabi is an intuitive appreciation of a transient beauty in the physical world that reflects the irreversible flow of life in the spiritual world. It is an understated beauty that exists in the modest, rustic, imperfect, or even decayed, an aesthetic sensibility that finds a melancholic beauty in the impermanence of all things.

When the tea masters of old were asked to explain the ideals of wabi sabi, in true Zen fashion they declined to offer a definitive version, but instead quoted the following poem by Fujiwara no Sadaie (1162–1241), which is said to capture the spirit of wabi sabi:

> As I look afar,
> I see neither cherry trees,
> Nor tinted leaves:
> Only a modest hut on the shore,
> In the twilight of an autumn eve.

Wabi Sabi and the
Japanese Character

WHILE STEREOTYPES often misrepresent individuals within a group, they do provide sociologists with trends of attitudes and behavior that allow comparisons between cultural groups. As German designs reflect commonly held attitudes toward quality and Bauhaus influenced economy of expression, so wabi sabi is a product of Japanese cultural values. A look at the people of Japan may show how this style of art has come to represent their social values.

As one of the worlds most physically and culturally homogeneous groups of people, the Japanese character has come under the spotlight on many occasions. However, as with her art, Japan exhibits a love for the undefined and vague, and this ancient tradition of subtlety has become manifest in the seemingly irreconcilable contradictions in her behavior. The Japanese aesthetic ideal of wabi sabi is the result of their predilection for the ambiguous, and as with all other cultures, the artistic output of a nation is a mirror image of the attitudes that pervade that society.

In the same way Japanese prefer art that provides ample room for ambiguity and a degree of obscurity, they also prefer a conversation not cemented with definite affirmations or negations. The social mechanisms in her society are the result of both the feudal discipline and the Zen tenets that have become assimilated into the national psyche.

Japanese people will rarely allow themselves to be drawn into a philosophical discussion, and yet their cultural values demonstrate

some of the most profound and consistent insights into reality—they live their philosophy rather than discuss it. There is a tendency in the West to theorize and analyze, but not to live lives that reflect the theories. As Kierkegaard pointed out, philosophers make wonderful palaces, but then live in the shack next door.

Few factors hold more sway on a national character than the weather. The temperate climate that Japan enjoys brings some of the most wonderful changes of season, and it is to these that the Japanese focus their interests and energies. Blessed with some of the most beautiful trees in the world, Japan in autumn or spring can be truly breathtaking, and the cherry blossoms have become one of the defining features of the Japanese calendar. During the brief time that the millions of cherry trees in Japan blossom, hundreds of thousands of small and large parties are held underneath them. Sake is drunk, songs are sung, and the fleeting beauty of the blossoms is enjoyed to the full. They are enjoyed in the knowledge that at the whim of the wind or rain nature can withdraw their beauty at a moment's notice. It is like a celebration of our own fleeting lives and is another way in which the Japanese can indulge their love of things impermanent. The changing of the seasons has always been a reoccurring theme in Japan's art and is often used to illustrate our own passage of time. For example, spring is often used as a euphemism for the sexual stage of life (the word *prostitute* is actually made from the three characters "selling spring woman"). And autumn and winter are paired with the latter years of life and are heavily used in the imagery of poets and writers (the term *autumn fan* is a way of referring to a woman who has passed her prime). Then too, when food is served, a leaf or flower of the season is usually placed as a decoration and reminder that everything has its season and that they must be appreciated. The passing of the seasons is a recurrent theme in wabi sabi expressions, and they are often used to provoke emotional responses.

In addition to their love of obscurity, the Japanese also tend to keep their emotions fairly well concealed. The straight face of your boss

may hide either affection or contempt; it is only the long and careful social training of the Japanese that allows the social codes to be interpreted. A foreigner coming to Tokyo for the first time might find the lack of emotion shown in public to reflect a cold and uninviting people. But for the Japanese, the disguising of emotions is in keeping with the Zen idea of remaining indifferent and aloof regardless of the circumstances one finds oneself. Sumo wrestlers are usually interviewed following a victory in one of the major Basho, sumo tournaments, but as it would appear vulgar and conceited to appear jubilant, they show complete indifference. A smile in this world of ancient traditions would be terribly frowned upon and would mean that the wrestler was under the illusion that his victory was important.

Kenkyo, or humility, appears throughout Japanese culture, from the many gifts given to express gratitude to the highly complex language used to show deference and modesty. As a culture that has had to depend on smooth group dynamics for its labor-intensive rice farming, the Japanese have never been a race to tolerate those who wish to appear different or better. This finds voice in the Japanese saying "The nail that stands up will be hit down." Humility with your fellowmen and humility in the face of the powers that guide our lives is a much-admired attribute in Japanese society and is constantly reinforced in schools and the workplace. Company presidents rarely award themselves huge salaries and usually eat in the same canteen as the manual workers. The subtlety of these social interactions even extends to the depth of a bow and in refraining from using an older person's name. Your elder brother is called just that, your boss is addressed by his job title, and doctors and teachers are all called by the generic term of sensei. It is this humility toward gods, ancestors, nature, and other human beings that has been absorbed into the way an artist or craftsman sees himself and his work. A Japanese carpenter for instance will treat his tools and the materials he uses with an intense reverence. His function is to try his best to bring out the wood's inner beauty in a harmonious way. When his work is done he will not be seeking praise or

gratitude for the work, for he has a personal sense of satisfaction that he has done his best and can do no more. This sense of modesty is the lifeblood of wabi sabi and saves the work of artists from being tainted by the pretensions or ambitions of an artist. Wabi sabi art must have this essential element of humility if it is to retain the purity of its spirit.

In addition to this sense of humility there is another way in which the Japanese maintain the smooth flow of social interaction. When discussing Japanese social behavior, the terms *tatemae* and *honne* are presented as the cornerstones of social lubrication. The tatemae is the face that one shows to society, the face that one is expected to show to society, but the honne is one's true heart, and one that often has to be carefully hidden for the sake of maintaining social equilibrium. To some foreign observers it may seem insincere or even dishonest, but for the Japanese it is the underlying rules for the unspoken way of behaving. Because of the complicity in the game, the rules are known by all and the signs read very clearly, whereas they might be completely missed by a foreign observer.

This lack of membership to the Japanese culture club makes it extremely difficult for foreigners, however determined they may be to learn the language or etiquette, to break into the group and be totally accepted. Conversely, it is also often difficult for Japanese to fit comfortably into Western groups, whose dynamics are governed by a different set of rules.

The enigmatic Japanese character that has brought them through one of the world's most remarkable histories will no doubt continue to tease and torment those in the West who try too hard to analyze and understand it. Like the French in Europe, the Japanese believe, and not without some justification, that they have a very refined social, culinary, and artistic heritage, although unlike the French they are able to remain a little more modest about their convictions. What they believe, *honne*, and what they say in public, *tatemae*, are not the same.

Refinement and insincerity walk a very narrow line, but as it would be far worse to offend someone, the most suitable course of action

is that which will maintain the status quo, and this is why the Japanese are such exceptional hosts. Anyone who has been fortunate enough to have crossed the threshold into a Japanese household will attest to the hosts unnerving ability to intuit his or her needs and moods. Hints given by the Japanese are so subtle that their reading of situations is finely tuned, so when foreigners, used to years of more direct communication, enter the scene, their moods and are often well anticipated.

The Japanese sensitivity to social occasions is mirrored in their sensitivity toward their art appreciation. They side with the vague and obscure, and the subtleties of their social makeup go hand in hand with the subtleties of their art appreciation. Wabi sabi offers the season-aware Japanese a perfect avenue for their social and aesthetic sensibilities to find a restrained but ardent voice.

As we move now into the twenty-first century, Japanese social norms are changing at an unprecedented rate. These changes in the fabric of Japan's culture are having a dramatic effect on the national character, and consequently their attitudes toward art and design. The youth in Japan have become very familiar with Western values as seen in movies and advertising, and now there is a pronounced swing away from more traditional values. Within the frenetic and crowded urban lifestyle, the space afforded to wabi sabi is certainly on the decline, and its future relevance in modern Japan is under threat.

Zen and wabi sabi have been the traditional foundations for Japanese artistic endeavors for many generations, but as the demands of modern life have forced a change in the requirements of art and design, so the complexion of Japanese society has also undergone a radical shift in values.

Wabi Sabi—
an Art in Transition

In his book *Lost Japan,* the rather unimpressed author, Alex Kerr, who had lived for decades in Japan, was of the opinion that from being one of the most attractive countries in the world when he first arrived, Japan had transformed herself into one of the most visually unappealing. For a country that has fostered such a strong aesthetic ideal, is Japan now severing ties with her artistic roots and leaving the wabi sabi aesthetic to languish in the annals of art history?

Those who believe that the demise of this aesthetic appreciation is all but complete might cite the modern architecture that dominates most urban skylines, which has shown a remarkable lack of restraint over the last fifty years. Since the collapse of the Tokugawa shogunate in the latter half of the nineteenth century, the Japanese interest in things from the West has been almost insatiable, ranging from the fashionable top hats of the nineteenth century to the modern-day culinary offerings of Ronald McDonald and friends. A trip from the incredibly modern Narita airport into the heart of Tokyo will not offer much in the way of aesthetic stimulation as the tangle of roads, overhead power lines, and buildings sprawl together in a none too attractive way. Once in town, the views offered are not much of an improvement, and a visit to a Japanese family house would probably dispel any preconceived notions of the stereotypical house with its simplicity and uncluttered interior. Most houses or apartments within

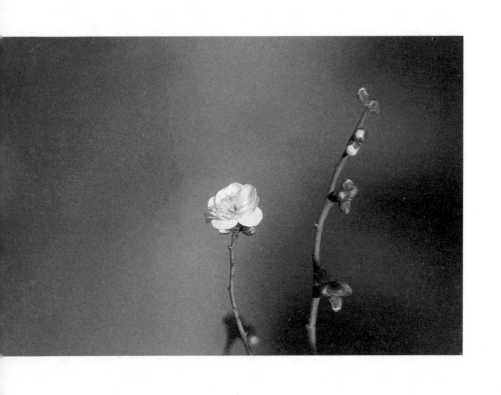

the densely populated cities are crammed full of modern furniture, household appliances, and neat storage devices.

The lack of beauty in urban areas is not, unfortunately, limited to the domestic scene, and Japan may justifiably be accused of spawning some of the most indescribably awful architecture. An example of which are the vast array of "love hotels" whose design themes include such oddities as Aladdin-style mosques and an imitation of the ocean liner the *QE2*. These hotels, which offer room for "overnight stays" and "one-hour rests," have blossomed because of the difficulty of finding privacy in the land of paper walls.

The *pachinko* parlor is another Japanese architectural disaster that one could say is the complete antithesis of wabi sabi. Pachinko is a form of vertical bagatelle where ball bearings work their way through pins and gates and in so doing can cause other balls to be dropped into the waiting tray at the bottom. The object of the game is to collect as many balls as possible, which can be exchanged for goods or tokens. These buildings, which can house hundreds of machines, are often tastelessly situated in the middle of attractive rural scenery decked out with a plethora of blazing pink and purple neon lights; they are glitzy, cheap, brash, noisy, money-oriented dens of iniquity that would make Sen no Rikyu turn several times in his grave.

It is a lamentable but undeniable truth that the artistic and spiritual peaks reached in days gone by are far more difficult to find in modern Japan. Beyond architecture, the modern tea ceremony has been accused of becoming spiritually vacuous by people like Yanagi Soetsu, a leading figure in the craft movement of Japan, who was vehemently opposed to the so-called high art that he saw bringing down the whole aesthetic sensibility of the Japanese. The overwhelming predominance of the material culture and the frenzied nature of modern life make it difficult for tea masters and participants alike to find complete abandon within the small tearoom. Rikyu's vision of a sublime meeting of kindred spirits has been somewhat lost in the ritual and near obsessive observation of etiquette and rules.

As with many of the Japanese arts, there is a great deference for all the principles laid down by the masters of yesteryear and an unwillingness to move away from the rules that have been handed down from generation to generation, however ritualized and meaningless they may have become. The modern tea ceremony has become a victim of this Japanese trait, and if some observers are unable to sip from the same cup as Rikyu, then this must be in part due to the stagnation of the art form and its digression away from its roots of simplicity, purity, and humility. As Rikyu said, "The tea ceremony is no more than boiling water, steeping tea, and drinking it."

Within the modern lives of urban dwellers wabi sabi holds very limited significance, and for many its demise it already a fait accompli.

This turning away from tradition and the full-scale adoption of more modern values and design parameters gives the impression that Japan has become a desert for the arts. But there is of course another side to the story, and with its wealth of natural beauty and peerless social refinement Japan is still able to offer those who seek it some unforgettable glimpses into the transcendent world that she has so carefully fostered.

A million miles from the "love hotels" and the uncontrolled urban sprawl, tucked away in the back streets of Kyoto, one can find the Tawaraya Hotel, an oasis for the seeker of the quintessential expression of Japanese hospitality. One could be forgiven for not even noticing the low-level building, as there is little on the outside to suggest the history contained within.

The guest is greeted personally at the front door and shoes are removed and replaced by slippers before the guest is then guided down small, softly lit wood-floor corridors to the door bearing the room's personal name. The kimono-clad hostess then kneels and slides back the door with consummate grace, giving you the first glimpse of your own sublime organic microcosm. There is no bed, no television, no harsh colors, just a display of exquisite restraint. Nothing stands out and yet there are visual treasures to be admired everywhere, including

the bathroom. In place of the normal Western bath there is a rectangular Japanese wooden bath, a pleasure that could bend the strongest will. They are made solely from Hinoki (Japanese cypress) without nails or glue and yet can remain watertight for decades. Although they look wonderful it is not until you are fully submerged, with the scent of the wood lifting your senses, that their full value can be appreciated.

Your own small garden is carefully framed by a window that allows just the right view, and the doors lead you out into the carefully designed miniature landscape. You have tea and a bath and then, in a loose fitting *yukata* (cotton kimono), you await the evening meal, which, as with most Japanese inns, is brought to your room. For the gourmand the food is a true joy as the vast array of flavors and textures are sculpted onto the handmade pottery, painting a picture of the season with the choice of ingredients and the flowers used for decoration. After a few cups of sake you might be ready to try some calligraphy using the writing set provided.

When you enter the inn you may feel worn and scuffed by the day's tensions, but on leaving, in the same way that your shoes have been polished, you feel your own equilibrium and vitality have been restored. There is no effort spared by the hostess in ensuring that your stay is an unequaled pleasure. Every move and every word said is the product of a mind focused on the perfection of her art, and it is in this world that one can still find the spirit of wabi sabi alive and very well.

The Tawaraya stands as an enduring icon of ancient Japanese culture, but one does not have to make a special visit to Kyoto to find wabi sabi in everyday life. Even in the metropolis of Tokyo one is never far from an old temple or garden, and in many homes the custom of an alcove with a scroll and flower arrangement is still commonplace. While the Japanese embrace new ideas, there is still a lasting reverence for the simple and natural beauty embodied in wabi sabi.

It is sometimes difficult to see how the Japanese live comfortably with their seemingly irreconcilable contradictions of style. Yet

throughout its history Japan has been a land of incredible paradoxes, and one wonders whether the Japanese ability to live with these gaping incongruities might in part be attributable to their Zen ideals of nonduality. If beauty and ugliness are just two sides of the same coin separated only by intellectual activities, then accepting their coexistence is not an issue. This may be one of the reasons for the physical development of modern Japan, where the sublime gardens of Kyoto might be flanked by a three-tier golf driving range. The Japanese seem to accept these apparent clashes with quiet resignation, and it is tempting as a foreigner to feel that more should be done to preserve the priceless cultural heritage. (Should Hitachi advertisements be allowed within the hallowed grounds of a Kyoto garden, even if they do provide sponsorship for the maintenance?)

Taking wabi sabi as an example of Japan's reactive approach to development, it is fair to say that as a commonly used and discussed issue, wabi sabi would be a marginal issue for most people living in modern Japanese cities. However, it is when viewed in its historical context that the relevance of wabi sabi to modern Japanese may be more obvious. Every person who grows up in Japan will come into contact with thousands of pieces of Japanese art, including pottery, poetry, calligraphy, flower arranging, gardens, temples—the list is almost endless. In isolation, these may mean very little, but taken as a whole they are continuously reinforcing the subliminal message inherent in wabi sabi, and as such will have a guiding influence on the aesthetic sensibilities of those within the environment. The longer a foreigner stays in Japan, the more he will become influenced by the sights he sees daily and by the tastes of the host nation.

If asked their opinion of wabi sabi, younger Japanese would probably shrug and say that's a tricky question. Yet the fact that today's younger Japanese may not articulate that wabi sabi is relevant only shows that they are not consciously aware of their cultural influences—not that the aesthetic ideals of wabi sabi are no longer relevant in the nation's psyche. The lengthy historical prevalence of wabi

sabi and its permeation into nearly all Japanese art forms through the years has left an indelible mark on the shared Japanese aesthetic appreciation. Far from being redundant, it still lives on through this cultural heritage and still plays an important role in the way the Japanese assess what is or isn't pleasing to the senses. It is in this unspoken arena where the force of wabi sabi sensibility is still exerting itself on the aesthetic sensibilities of modern Japanese people.

It lives on in the simple clean design of the first Sony Walkman, in the austere and sober Ando architecture, and in the handmade pottery that is still a feature of everyday life. Cynics may have written off wabi sabi as an archaic style that has long since ceased to sway the modern Japanese, but in the love of seasons and the keen awareness of life's impermanence they still retain a deep appreciation for things wabi sabi—an appreciation impervious to a millennium of change.

ART

Wabi Sabi in the Japanese Arts

As a FUNDAMENTAL building block for Japanese art, wabi sabi has influenced many of the Japanese art forms as they have evolved over the ages. With the essential Zen philosophy staking out the foundations, the monks and other artists worked to create a very diverse range of artistic expressions including gardens, poetry, ceramics, and flower arranging, to name but a few. Many of these arts gravitated around the Zen cosmic view and so could not help but share many of the aims and characteristics of wabi sabi. In this section we will look at the way the arts have been influenced by wabi sabi, and how the sentiment of wabi sabi is still found within their fabric.

Garden Design

Japan's first gardens were inspired mainly by Shinto beliefs and were initially no more than open gravel spaces where it was thought that *kami*, or spirits, would be encouraged to visit. To these simple beginnings were added rocks and trees where the kami were thought to reside, but it was not until the Kamakura period that the Zen ideals started to make an impression on the art of garden design.

It was in this period that the *ishitateso*, "the monks who place stones," were given the task of designing temple gardens using large rocks as their primary mode of expression. The reverence for the Chinese landscape pictures that came from the mainland during the Song dynasty found a voice in the garden designs of the Zen monks,

who used the themes of ethereal mountains and rivers to build their microcosmic gardens, known as *karesansui*.

Armed with a frugal selection of raw materials the monks sought to build worlds within worlds as their gardens became miniaturized versions of the cosmic order and their rocks took on the stature of mountains. As with other wabi sabi designs, they deliberately left the gates open for the flow of imagination to enter. Their designs imbued the gardens with a sense of the surreal and beckoned viewers to forget themselves and become immersed in the seas of gravel and the forests of moss. By loosening the rigid sense of perception, the actual scales of the garden became irrelevant and the viewers were able to then perceive the huge landscapes deep within themselves. This expanse is a key aspect of Zen, and the nothingness that it symbolizes is not the same as the nothing we understand in the West. It is the indefinable infinite that both surrounds and lies within us. The solitary rock surrounded on all shores by a sea of gravel was synonymous with our own existential position, not only with regard to our fellowman but also the eternity that envelops our very being.

Rather than aim at superficial beauty in their work, the Zen monks responsible for many of the timeless designs were more interested in mirroring universal truths. They were beckoning others to release themselves from the tyranny of reason and to discover the truth that runs beyond the realms of our day-to-day perceptions. Just as our eyes only perceive the dry gravel streams, so our minds are missing the great river that courses through the fleeting world.

The most famous of all Japanese gardens, Ryoanji, was constructed in 1450 under the guidance of the artist Soami, and it displays a completely different philosophical axis to the garden designs of Europe, such as those of Versailles. The French gardens were large and physically impressive, but in keeping with wabi sabi, Ryoanji was intimate and subtle. It posed a metaphysical conundrum and sought not adulation but the stimulation of those who beheld it.

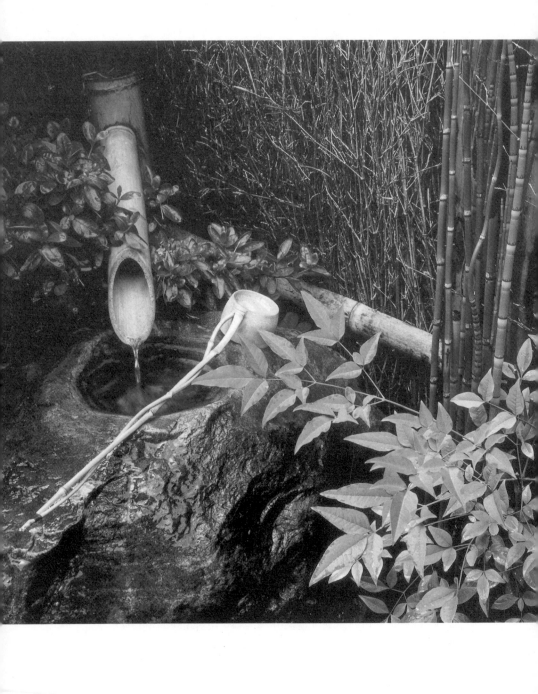

Many wonderful theories have been put forward about the place-ment and significance of the fifteen stones in the garden of Ryoanji, but words tend to tie us to intellectual thoughts, and this was not the reason for building such gardens. It is only by really looking at the garden with a clear mind of *muga* (no self) that the depth of the gar-den becomes apparent. As with many other wabi sabi expressions, there is a strong sense of challenge to the observers. They are not being invited to just sit and enjoy something that looks appealing, but to become actively involved in understanding more about the garden as a metaphor for the universe.

The Japanese have a love of vague words that is only equaled by their passion for giving things names. Within the field of garden design there are now over one hundred different Japanese words used just to describe the different rocks that can be incorporated into a design, but there are those who feel that this tendency to overclassify actually blurs the main aim of the garden. Until very recently there has been a tradition of teaching gardening that has given no quarter to the verbal communication of ideas. Over a period of ten or so years a trainee gardener would work with a master and absorb his master's knowledge without recourse to learning rules or theories. The osmosis of this knowledge, passing seamlessly from one to another, shows the spiritual nature ascribed to the work of the gar-dener and emphasizes the efforts required to become a worthy land-scape artist.

Tea Gardens

As an integral element of the tea ceremony, tea gardens (*roji* or *chaniwa*), were designed to complement the ambience and set the scene for the whole ceremony. Like so many aspects of the ceremony, a great deal of the design work was inspired by Rikyu, who felt that the walk through the tea garden on the way to the ceremony should be akin to a peaceful stroll through a desolate mountain trail. With

its close relationship to the tea ceremony, the tea garden became one of the richest expressions of wabi sabi. By working hand in hand with nature there was a sublime synergy between the artistry of the tea master and that of the earth as it breathed life into the bamboos, trees, and shrubs.

Usually small and intimate, a tea garden would have many elements of wabi sabi-style design, including irregular stepping-stones, used to reach the tearoom from the *machiaishitsu* (the place where the visitors meet before entering the tearoom); austerely sculptured pine trees; verdant moss on stones vibrant with subdued hues; and decaying bamboo fences. These gardens, constructed with infinite care, used the stepping-stones to guide the visitors as they made their way to the tearoom. They were designed to instill a focused and refined state of mind so that upon entering through the low door of the tearoom the participants were ready to communicate not so much with each other but with the spirit of tea.

In order to find the spirit of wabi sabi in gardens, it is again the perceiver who will need to make the effort to unearth the wealth of stimulation awaiting discovery. The gardener sets the scene and provides the potential, thus leading the proverbial horse to water, but having done this, he must retire and rely on the sensitivity of the visitor to use the garden as a springboard to grasping the eternal truths etched throughout.

Wabi Sabi in Poetry

In Japan, as in many other cultures, the art of poetry has long been used as a means for the transmission of delicate and deep feelings that normal language cannot hope to adequately convey. Poetry can express undefined feelings and unvoiced thoughts. The Japanese poet will use the bare minimum of expression to provoke the greatest emotional response, and this *yojo* (literally "extra emotion" or "suggestion") is an ever-present theme in wabi sabi. It was said by Japan's

most famous poet, Basho, that "a poem that suggests 70–80 percent of its subject may be good, but a poem that only suggests 50–60 percent of the subject will always retain its intrigue."

In normal conversation and literature the Japanese adore the vague and obscure, but in poetry we find the most exquisite expression of their love of the ambiguous. The Japanese script, which is based on the Chinese pictographs called Kanji, carries a strong emotive force in its own right. However, with the flow of brushed black ink on a silk screen, the impact of the dynamic characters combined with the wealth of meanings they imply can be breathtaking. It is a synthesis of poetry and graphic art that ensures its status as one of the most esteemed art forms in Japan.

While poems in the West tend to be longer and more expressive, the Japanese short poems, tanka, and especially the haiku, are very brief and only give the defining attributes of a scene rather than describing it in full. By withholding verbose descriptions the poem entices the reader to actively participate in the fulfillment of its meaning and, as with the Zen gardens, to become an active participant in the creative process. There is also a conscious decision to do away with anything that might taint the poem with the personal sentiments of the poet. In Japan, poems should not be tethered to the entanglement of a person's ego. Humility, modesty, and a keen eye for small details in the natural environment are key attributes. As Basho said, "If you want to learn about the pine, then go to the pine, if you want to learn about the bamboo, then go to the bamboo. When you have become one with them, then your poetry will come by itself."

The sentiment of sabi has traveled hand in hand with the Zen movement, and in poetry, more than any other medium, the sense of desolation and loneliness became especially poignant. The following poem, by the twelfth-century poet Jakuren, shows the way an artful poet can give full voice to the depth of his sentiments. There is the greatest restraint from indulging in personal sorrow, but the poet is still able to share with us his sense of being utterly alone through the

analogy of a solitary mountain tinged with the melancholy hues of an autumn eve.

> To be alone
> It is of a color that
> Cannot be named:
> This mountain where cedars rise
> Into the autumn dusk

The haiku style of poetry, which consists of an unrhymed verse written in a 5-7-5 syllabic form that is normally written in just three lines, is the quintessential Japanese poem and Basho was perhaps its greatest exponent. His economy of words and ability to blend humor with a wealth of unspoken meaning brought an exceptional quality to his work. He was also credited with establishing the sentiment of sabi as a definitive emotive force in the creation of haiku. Its touch can be felt in the work of many other poets, but it was Basho who elevated its status and use. Indeed, it was the honesty and starkness of his style, coupled with a superb ability to observe even seemingly insignificant aspects of nature, that have made his poems impermeable to the tides of change.

One of the great catalysts in Basho's life was the premature death of his close friend when the budding poet was just twenty-two. To recover from the grief and desolation felt on the passing of his friend, Basho started on his first pilgrimage to contemplate the meaning of life and the reasons for its unavoidable transience. It was at this time that the element of *sabishisa*, or loneliness, first became apparent in his work, an example of which is:

> Along this path
> There are no travelers . . .
> Autumn evening

As with other wabi sabi expressions, there is no sentimentality, no superfluous adjectives, just a devastating imagery of solitude. The

use of autumn, a *kigo* (seasonal word), implies the coming of old age and the sense of existential loneliness felt in our solitary journeys.

At the age of twenty-eight, Basho decided to renounce the world to focus his considerable energies on the practice of Zen. The influence of his Zen teachers left a deep impression on the young Basho, and through his rigorous spiritual training he was able to further attune his mind with the rhythms of natural surroundings. It was this great love of nature, coupled with a keen awareness of the evanescence of life, that provided the melting pot for some of the world's finest poems. His most celebrated poem is:

> *Furu ike ya!*
> *Kawazu tobikomu*
> *Mizu no oto*

> The old pond
> A frog jumps in
> The sound of water

As with most haiku, the images are taken from the small details found in nature and then the imagery is used to paint a thousand pictures and convey sentiments that elude verbal definition. The old pond could be a landscaped water feature in an old Japanese garden, but it could equally represent the eternity that surrounds us, or even the unknown we enter into with death. The frog, whose life may seem rather insignificant, could be like Shakespeare's player fretting and strutting its hour upon the stage. The sound of water may then mean the passing from life to death or the flash of realization of satori, or maybe it refers to the awareness of Basho as he saw-heard-felt the frog entering the water and became one with the frog.

The length of a poem is inversely proportional to the multiplicity of meanings it can convey, and as with homeopathic medicine, it is the very brevity of the haiku that makes their effect so profound. It is therefore the task of the poet to condense into the bare minimum

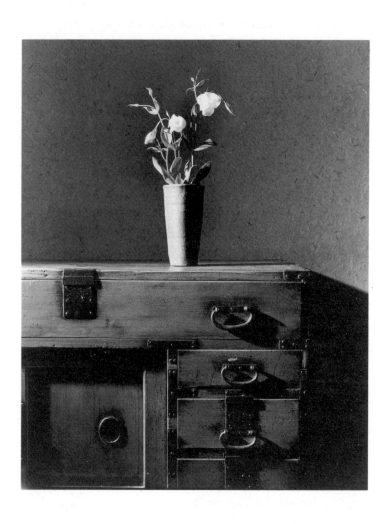

sentiments that will hold the maximum inspiration for the intuitive imagination of its readers. As a tea master will endeavor to make his simple wabi sabi expressions as poignant as possible, cutting away anything that is superficial, so, too, the poet pares away all unnecessary words and images to leave a clear vision of the essence of life.

WABI SABI AND CERAMICS

Japan's history of ceramics stretches back over ten thousand years and the vast array of uses offered by the clays that are so abundant throughout the archipelago have had a lasting impact on the cultural development of Japan over the millennia.

Not surprisingly, the majority of the initial techniques were adopted from mainland China, but as with so many things Japanese, there was a desire to take an idea and then, through study and effort, improve on it. Today, Japan has probably the greatest pottery tradition in the world, which is supported and encouraged by a population that still greatly values this medium for artistic expression. Like other styles of pottery, Japan's ceramics have a vast array of colors and forms, but unlike many in the West they rarely have handles, as the tactile nature of the pots makes handling them a part of the pleasure.

In medieval Japan, under the patronage of the Zen monasteries and the Kamakura shogunate, the prevailing preference for simplicity and modesty were slowly introduced into the styles of the ceramics produced. So while there was still a huge following for the finer, more elegant pieces of Ming porcelain, interest in the more rustic pottery was on the increase. The new pots were rarely decorated; instead, the uneven texture of the ash glazes was preferred.

The ornate ceramics from China that were so prized by the court and the wealthy ruling classes were considered too ostentatious by the Zen masters and became less and less attractive to Japanese aesthetic sensibilities. The potters expanded their horizons from the leash of symmetry and uniformity and started a move toward a more robust and free expression of beauty.

Rikyu took the baton of artlessness from his predecessor, Ikkyu, when he introduced Korean craft pottery into his tea ceremony. The Korean potters, who might have made a hundred similar pots in a day, were probably totally devoid of any thought of artistic aspirations as they worked, and it was just this lack of intellect that proved so attractive to Rikyu. Rakuware, which later became synonymous with tea utensils, was in fact first commissioned by Rikyu after he noticed the visual qualities of a locally made roof tile. He asked the tile maker, Chojiro, to fashion pots using the same low-fired technique. Years later, Hideyoshi gave this style his approval by awarding a gold seal to Chojiro's son with the character *raku*, which means pleasure. This identification of a potter as an artist was a break from the tradition of the nameless artisan and was to set a new precedent for Japanese ceramics. The raku tradition and family line continue to this day, although how much of the original spirit and artistic value is left is open to question. Yanagi suggests that even the school of raku, with its humble beginnings, soon became tainted with intellectual processes and the artificial pursuit of beauty, becoming but a pale imitation of the former purity achieved by the craft potters of Korea. In becoming so esteemed and sought-after, the first magical qualities of the wabi sabi style of pottery were diluted by the pressing commercial considerations that started to overshadow the cult of tea.

Rikyu's positioning of rough and unrefined pots on a par with, or even above, the prestigious wares owned by the nobility was a defining moment for Japanese aesthetics. As the accepted national authority on taste, he was able to shift the focus of the tea utensils toward simplicity and humility and away from the beautiful Chinese artifacts, clearing the way for the appreciation of ceramics that bore all the hallmarks of the wabi sabi sentiment. These more rustic-style bowls and tea utensils distilled the power and randomness of the flows of gases and ash in the kiln and their asymmetry offered almost endless potential for aesthetic appreciation. If a bowl is supposed to be perfect in its form and glaze, then, apart from the inevitable flaws

that it will have, there will be less to hold the attention. By making something symmetrical the artist is giving little opportunity for the beholder to add anything to the piece, since it is supposed to be complete. On the other hand, by making asymmetrical pieces or pieces that may appear physically imperfect, the artist is offering an opportunity to get involved in the piece and to help complete the picture, or to even reflect on the seemingly imperfect nature of life itself. Ironically, some of the most prized bowls in history are those that have been initially discarded by the potters who made them.

With the development of new kilns that provided greater heat along with the ability to create oxidizing and reduction atmospheres, the potters suddenly found themselves with a multitude of colors, forms, and textures to choose from. They also found a very supportive and well-educated market that was looking for the perfect balance between the organic and the refined. The result was the blending of the humble potter with the spontaneous qualities of natural fired clay. It has been said that wabi sabi pots are not perfection, but in fact, they have gone a step further, for they have relinquished the desire for perfection to reveal a truer and more beautiful view of life.

The lengths that potters have gone to achieve this "more than perfect" imperfection are extreme, and their kilns became more and more complex to improve the firing qualities. The Anagama kiln, which still holds center stage in modern Japanese pottery, is a wood-fired kiln that takes at least four days and nights of hard physical work to fire. The potter must test his own mettle and resolve during the firing, and it is his mental state that will determine the final outcome. The kiln is a kind of climbing system with one or more chambers that house the pots to be fired, and because of their size and the logistics of firing they will only be fired a few times a year. Large quantities of pine and other softwoods are fed into the kiln so that the force and heat generated by the gases becomes extremely high and the ash being produced is thus forced through the kiln and then up through the flue.

It is the sporadic journey of the ash that is of interest to the potter, as it is often only the ash that provides the necessary glaze. So it is the position of the pot in the kiln that determines how and where its glaze will be formed. The potter struggles to find the shapes that are hidden in the raw clay, but once he has done his utmost to bring from within himself a pure shape, he will then carefully select a section in the kiln before abandoning the pot to the whims of the ash. Every firing is different, and the results will vary enormously, so it is with some trepidation that the kiln is opened and the pots brought from their fiery tomb.

The potter will look carefully at each pot and only then will he be able to say whether the firing has been a success. No piece in the kiln will be exactly the same either in shape, texture, or glaze, and herein lies so much of its appeal. After a firing there will usually be a group of enthusiasts waiting to see and maybe purchase the fruits of his labor. Despite the great difficulties and unpredictable nature of this kind of firing, it is still thought to produce the best ceramics due to the part played by nature and the organic ash glazes. Little has been done in Europe with ash glazes, but in Japan the ash glaze has been a predominant feature of pottery since its use was first discovered in the Nara period. The desire for a nonuniform surface that can catch, in the glaze of each pot, the irregularities of nature hails back to the Japanese love of things that are imperfect and incomplete.

When one picks up a tea bowl that has been fired with a random ash glaze, it is hard not to be entranced by the range, depth, and flow of colors that the ash has produced—the kiln has left its indelible mark on the piece. It is not hard to understand why the tea masters and Zen monks were so drawn to this art form, which seems to provide a perfect harmony between the hand of the craftsman and the hand of nature. In such pieces of pottery can be found some wonderful wabi sabi nuances, and it is this visual and tactile appeal of pottery that has made it such an important part of the tea ceremony. During the tea ceremony, guests are invited to handle and appraise

the utensils. This is an integral part of the whole experience; one where the guests have a chance to admire bowls that have been handed down through the ages, bowls that may once have been caressed by the hands of shoguns.

The idea that inanimate objects have kami—a spirit or god—is an unquestioned certainty for most Japanese, and objects such as special trees or rocks are often decorated with a white rope to draw attention to their special kami. This is in part a result of the long tradition of Shinto in Japan, where kami exist in heaven and on earth and manifest themselves not only in the form of deities but also in natural phenomena and objects of the world. For the Japanese, there is continual flow of spirit, and each person is a part of the great spiritual whole. A bamboo vase handed down from Sen no Rikyu may be falling apart and unable to hold water, but as the possession of a person with great kami, it is believed to still hold Rikyu's spirit. It is believed that the kami of great men lives on in their possessions or works.

In touching the revered utensils used in a tea ceremony, the feeling of history and spirit are thus passed on to the guest and help to further enhance the spirituality of the occasion. Whether this intangible spirit is an element in the wabi sabi aesthetic is difficult to say, but we often do seem drawn to objects that have a patina showing the passage of time and continued use. It is not unreasonable to suggest that we are in some way unconsciously drawn to some ineffable qualities with which an object has become imbued during the years of its use. The pots handed down from generation to generation seem to grow in their aura, and the effect that humans have and leave on an object, although they fall well outside the domain of reasonable scientific thought, become the focus of attention and reverence for the Japanese. For ceramics, whose frail appearance belies a resilience to physical decay, there is an ability to span many generations and for their expressiveness to increase through the years of use. This consistent element in the tea ceremony has helped to ensure the importance of ceramics not just in tea but also in Japanese society as a

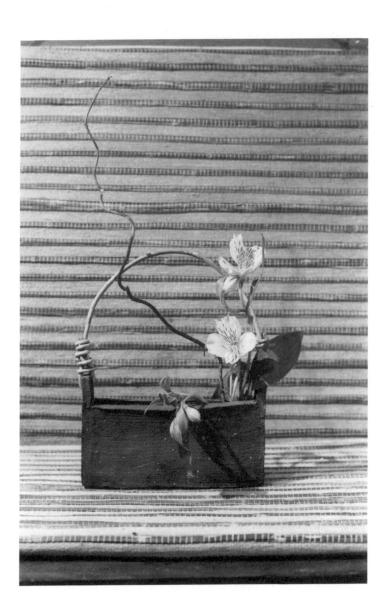

whole.

Food is without doubt one of the most discussed and enjoyed activities in Japan. Ask a Japanese traveler how his overseas holiday was and, nine times out of ten, the first topic he mentions is the food. It is to the love of food that ceramics owes its continued survival, and despite changes in society there is still a great national appreciation for good food served on attractive pottery. There are literally thousands of potters in Japan who enjoy the status of artist. There are, of course, mass production systems that can make a thousand similar pots in one batch, but the Japanese love of pottery with a personal and unique feel continues to ensure its highly regarded eminence in Japan today. The types of pottery made today, including Bizen, Hagi, Raku, and Shigaraki, are still based largely on the aesthetics developed centuries ago, and a visit to a contemporary ceramics dealer in Japan will leave no doubt that the wabi sabi aesthetic is still a key.

JAPANESE FLOWER ARRANGING

Ikebana (literally "living flowers"), or the Japanese way of the flower as it is sometimes known, finds its roots way back in the seventh century when the Chinese custom of placing flowers as an offering to the Buddha was introduced into Japan. It was then a full eight hundred years before the first systemized form of flower arrangement, known as *rikka*, started to find favor. The rikka style, which means standing flower, was more sophisticated than the Buddhist offerings and more formal in its rules. There were seven branches symbolizing the peak, the hill, the waterfall, the town, the valley, the side receiving sunlight, and the side in the shade. It was built around the Buddhist cosmic view, and because of the constraints on the form, the rules tended to overpower the final aesthetics.

Not surprisingly, Sen no Rikyu, with his dislike for rules and contrived forms of beauty, felt that the real beauty and aesthetic value of

flowers lay not in there adherence to rules but to the way in which they were sympathetically displayed.

It was Sen no Rikyu who started the nagaire movement, which means to "throw into," and it is here where the spirit of wabi sabi can be found. Doing away with all formalism and again refraining from using opulent vases from mainland China, Rikyu remained true to his overall aesthetic scheme and chose the simplest of vases for the flower displays in his tea ceremonies, known as *chabana* (tea flowers). In place of more impressive flowers Rikyu insisted on the use of smaller wildflowers picked in the fields. He is said to have been the first to introduce the bamboo vase as a serious artistic expression, and the first vase used, called the Onjoji vase, has been treasured ever since. Even when the vase started to leak, the small pool of water that gathered around the bottom was appreciated as a natural flaw, beautiful and expressive in its own right.

On one occasion Rikyu had heard of Hideyoshi's desire to see the beautiful morning glories that were in flower in the tea garden. Following protocol Hideyoshi was invited, but on his arrival he was surprised to see that all the morning glories had been cut. However, on entering the tearoom, Hideyoshi noticed an exquisite flower arrangement that consisted of just one beautiful morning glory. Rikyu was showing his master that the truth of real beauty did not lie so much in the beauty of a field of flowers but in the contemplation of the life of just one. By focusing on just one flower one might be able to break the perceptual gap that lies between the flower and oneself and to realize that the flower and oneself are not after all existentially separate.

Ikebana, like the gardens, uses a living medium in the creative process, and it is this ingredient of life that brings a unique feel to flower arrangements. Under Zen doctrine, all plants are seen as sentient beings in their own right and should be accorded this respect. The flower arranger from the nagaire school would show the greatest reverence for all life, and in this mood of humility allow the flower to express its own beauty without forcing it to fit some man-made construct. After the flower has passed through the different stages of

its evolution and has played its part in the artistry, it will be laid to rest with the greatest respect.

The mood of the flower artist, then, as with the potters, gardeners, and poets, shows a deep respect and humility toward life, allowing the expression to come from nature rather than a man-made construct. The minimal expression used in chabana flower arranging is again reinforcing the idea that less is indeed more and in some ways the work of an artist is as much in what they refrain from adding as what they actual put in.

Defining Aesthetics

"All art is quite useless." —Oscar Wilde

AS A LITERARY ARTIST of great stature, this comment by Wilde provides an interesting starting point for a discussion on the nature of art. By initially negating the value of art, the onus is on the student of art philosophy to show that art has a value and what that value might be.

Looking at art in terms of its function will show the different ways in which art is used and more specifically the function that wabi sabi art can fulfill. Art is an integral part of life as it is the way we express ourselves and the way we feel about our environments. We can communicate verbally, in body language, even in silence; art is a way in which ideas and emotions can be shared. As Zen puts no store in language, the monks' art took on the role of communicating profound truths, and the function of wabi sabi art was primarily the transference of spiritual knowledge. It was a vehicle for the Zen monks to share their insights.

What Is Art?

The apparent innocence and simplicity of the question "What is art?" belies the incredible scope that such a question covers, and despite intense efforts by the world of academia, a concise and universally accepted theory of art still proves illusive. There are almost as many

theories on art as there are forms of artistic expression, and most of course are firmly rooted in the Western mind-set—a view that is prone to scientific analysis. This is radically different from the more intuitive approach that is prevalent in the East, and thus the current debate on art has become tainted with a very Western philosophical flavor. Since the fundamental starting point for Western understanding of the world is essentially determinist and Newtonian, it is limited in its ability to tackle the more metaphysical and ontological aspects of Eastern art theory. In order to have a more holistic view of art, and especially art from Japan, it is necessary to start any discussion from the very first assumptions on which our worldview is based.

In artistic expressions there is the creator and then there is the person who perceives and assesses that which has been created. However, the scope of expression is so vast that no tangible barriers define the perimeters of what art is and what is just living. It has been suggested that *everything we do, every gesture and every movement is in fact art*, as it is the way we are expressing ourselves in the face of the environment with which we interact. This all-encompassing idea is, in fact, quite in keeping with Zen philosophy, which seeks to find artistry in every aspect of life. The term *seishintouistu* refers to the concentration of the mind and spirit on just one activity, and through this constant mental discipline the person is able to loose the dominance of the ego and become one with the activity. The artistry is the result of a mind focused on the task in hand, whether it be polishing a floor, raking gravel, or cutting vegetables. By bringing the mind to bear on the here and now, everyday activities can take on profound meaning and in Zen these are considered key for the development of the mind. This attitude can then transform the most mundane tasks into art.

Zen teachers stress a state of mind called mushin, which could be likened to a state of total absorption in a task. This concentration helps subdue the ego so that mind and body can work in a free, natural, and uninhibited way. This erasing of the importance of self is seen as key to producing art that is not tarnished with the hues of

self-indulgence or self-promotion. In his book *Zen in the Art of Archery*, Eugene Herrigel tells of his efforts to try to comprehend Zen through the study of archery. His teacher patiently helped the German philosophy professor to gradually diminish the role of his intellect when drawing the bow until, after years of earnest practice, he finally managed to loose a shot in the right spirit. The seemingly simple act of letting go of the string without mental deliberation or intention was the first monumental step he had to make before proceeding to even shoot at a target. For his teacher, the hitting of the target was completely irrelevant to the art he was trying to teach, as it was only a physical manifestation of a truth that the archer already knew. If the archer and the bow are in harmony and the ego takes no part in the activity, then the shot will be made in the right spirit and that is all that matters.

After many years of effort his master took him aside and showed Herrigel how the forces guided the arrow and how he was merely a conduit for those powers. After hitting the center of the target with the lights on, he then went on to split the first arrow with the lights turned off. Instead of taking any credit for this rationally impossible feat he just humbly explained that "It did it."

The master aimed to teach Herrigel humility and to be indifferent to the final outcome of the shot. Whether he hit the bull's-eye or missed the target there had to be complete equanimity, for it was not in fact Herrigel that was loosing the shot but the unspoken powers that guide men's lives. It was only by accepting this that Herrigel could then allow the arrows to be shot through him rather than by him.

In other arts, too, the role of the artist is that of a medium rather than an individual. This idea that the artist is not really the creating force is an underlying theme in the arts of Japan, and it is the supreme achievement of an artist to reach the levels where conscious effort and thought are abandoned to the dictums of the unseen forces that guide our lives. It is therefore the spirit of the artist at the moment of performance that is the criteria by which art is judged in

Japan. Calligraphy, for instance, which is one of the most highly respected art forms in the both China and Japan, is said to be a perfect reflection of the state of mind of the artist at the time it was written. When preparing to write, a calligrapher must summon a serene and focused mind that will guide the brush swiftly over the paper. The whole process is meditative, from the opening of the writing set, through the steady grinding of the charcoal stick to make the ink, to the intense concentration of brush on paper.

Defining art is as difficult as defining life itself, as the two are inseparable, but art may be better understood in terms of what it has to offer mankind.

The Value of Art

The importance that the Japanese attach to works of art is sometimes hard to put into context, but the following story may illustrate the strength of feelings that art can arouse. A samurai had been asked to look after a much-prized hanging scroll, but while his master was away a fire took hold of the building. In order to salvage the work of art he bravely reentered the room where the scroll was kept only to find that his exits had been cut off and he had no means of escape. In an act of almost unbelievable bravery and willpower he drew his sword and cut a tract in his abdomen before the flames consumed him. On closer inspection of the charred body the scroll was found unscathed by the fire, safe within the samurai's abdominal cavity.

From a Zen perspective, works of art that are done in moments of enlightenment are indeed mediums for others to grasp the ungraspable. They are imbued with the magic of the moment of creation and are to be accorded the greatest respect. Even Ikkyu, who was a staunch advocate of nonmaterialism, treasured the works of art handed down by his father, the Emperor Go-Komatsu, despite having thrown his certificate of enlightenment back at his teacher.

The value of art has been categorized in terms of what it can give to us as humans. The three main functions that art serves fall into one of three categories: *emotional expression, communication of ideas,* or *amusement*—and some art may even satisfy all three at once. The Zen monks used the arts as a vehicle for the serious business of communicating their understanding of life to their fellowmen, but within their work there was also humor, satire, and an exquisite sense of beauty. The Daruma (the Japanese term for the Bodhidharma), so often mercilessly caricatured by the Zen monks, was often drawn in a few intense minutes, with little respect accorded to the monk, considering his historical importance. But this intentional lack of deference shows another Zen way of ensuring that nothing becomes sacred or more important than anything else. One monk tore up his master's scrolls when the master appointed him his successor. The master yelled, "What are you doing," and the monk replied, "What are you saying."

The idea of lampooning the Christian figurehead has probably not occurred to many ecclesiastic artists, and in days gone by the punishment for such blasphemy would have been severe if not capital. However, for Zen monks, nothing was sacred, and this allowed the dimension of humor to enter much of their work. Despite this humor there was still an incredible veneration for pieces that managed to catch the fleeting spirit of enlightenment. The Japanese actually attribute Buddha Nature to some pieces of art, and this idea of the transference of spirit or kami is also found in their Shinto beliefs. Japanese value art for the wisdom it enshrines and for its ability to transfer this wisdom to others. But for true wabi sabi art, it is the impermanence of the piece that makes it so special, and therefore a large part of the value accorded to it lies in its ephemeral nature and in the fact that the same moment will never come again. Like valuable paintings in the West, highly prized tea bowls may be kept in museums, but the true appreciation of simple and humble crafts, which is the lifeblood of wabi sabi, is too fleeting to stand this testimony, and only the shape of the bowl will remain.

An essential element of wabi sabi is innovation and originality and bringing in new challenges for the mind to explore. Creativity is an integral part of the artistic process. It provides the new ideas and inspiration for new arts and seems to be an essential element in developing new types of expressions. It is usually assumed that creativity is something all humans are capable of to some extent, and few would question this—except possibly Zen monks.

If, as Zen maintains, we live in a world of consciousness, where our every thought and feeling is compartmentalized to fit the constructs of our mental grasp of the world, then what we refer to as creativity may just be the rearranging of these constructs in a clever and artful way. The actual creation of something completely new may be a lot rarer than one might have thought. If we wish to be truly creative, then isn't it necessary to go beyond the rearranging of symbols to produce something that comes from the very source of our being?

The answer may be that only those who have transcended the boundaries of dualism, who have succeeded in stopping their internal dialogues, who are able to perceive the world in its "is-ness" are able to be creative in the truest sense of the word. The value accorded to art in the past, particularly in the East, has been the transference of this magical insight into a physical manifestation of the inexplicable world that the enlightened artist perceives. But if the artist has not drunk from this bottomless well, then does his art have any real spiritual value and is his art able to provide anything other than intellectual amusement? This is a crucial point when considering the value of art, and although art for pure amusement may have its place in society, the art of wabi sabi usually has its sights set on the furthering of spiritual awareness and the enhancement of the environments we live in.

As the role of religion in Japan and other countries is in decline, it seems that art's role as a source of amusement has become more predominant in the womb of materialism. As such, its ability to amuse

through intellectual stimulation is becoming a dominant factor in its raison d'être.

The role of art, its function and therefore its value have all changed radically over the last couple of centuries. The pace of change is greater than at any time in man's history and it is bringing with it huge social changes that have a considerable effect on our psychological well-being. As the aspirations for life are changing, there is a need to find something that is constant and fulfilling, and it is here that art may be able to provide an invaluable reference point to remind us that life is still an intensely magical experience. It is now that art should be trying to light the way toward a more balanced approach to life in a modern world. As an art based on a philosophy of disciplined non-materialism and nonrationalism, wabi sabi may be able to inject some perspective on the unrestrained hedonism of today.

WHAT IS BEAUTY?

As suggested earlier, the idea that beauty exists in its own right is untenable not only to Zen theory but also the vast majority of academic opinion. Beauty is probably best defined as the aesthetic pleasure gained from perceiving something that one believes to be physically attractive. That the rough, asymmetric, and modest objects of wabi sabi are considered by some to be the essence of beauty illustrates that a rational or objective approach to understanding beauty will probably yield little. Our reaction to art is conditioned by our social upbringing and also by what we seek to gain from art. As the Japanese have developed an appreciation of things wabi sabi in accordance with their philosophy, so other cultures have found beauty that represents their own characteristic worldview.

The pygmies in the central African rain forests sharpen all of their front teeth to points to enhance their beauty, while in Japan it was an ancient custom for women to blacken their teeth. That small feet were considered alluring in China is now an idea that is a little hard to

relate to in the West, and how might renaissance painters have captured the heroin chic image of semi-emaciated, ashen-faced supermodels recently in vogue with the glossies? Even in the very limited arena of physical human appearance our ever-shifting tastes show the difficulties in applying any sort of standard or yardstick to the idea of beauty. Fads and fashions come and go, but it is individual people who must decide the artistic value of something as all beauty lies in the sphere of perception. The perception of beauty, whether visual, audio, or tactile, forms the fundamental building blocks of art.

The herd instinct that underscores man's status as a social animal seeps from our every pore and its influence is clear in the field of aesthetic appreciation. Values are slowly developed as we are encultured by our surroundings, and these values also include those of aesthetic judgment. The Japanese, who have one of the world's most homogeneous societies, also have a very strong convergence of opinion on matters of taste. There is a significant if not overriding element of learning in the process of art appreciation that becomes ever more pronounced in the age of media dominance. And yet, despite this factor or learning, there are still many in the West who seem to have an intuitive liking for things wabi sabi, even if they are completely unfamiliar with the Japanese ideology.

Although all people are indeed different, with cultural backgrounds playing a large role in defining what people perceive to be beautiful, there seem to be some elements of visual aesthetics that bridge the gap between the different cultures and allow for a tentatively objective view of a shared aesthetic ideal. These elements might include balance, color, proportion, texture, or resemblance to naturally occurring phenomena, and when combined can provide some sort of guidelines for the production of work that might be considered pleasing to the eye. Mathematicians have invested great efforts to try and break the code of beauty and to find the complex formula that may somehow underlie these shared aesthetic values, but for the time being they remain just theories.

Theories come and go, but in putting the appreciation of wabi sabi beauty into historical perspective, it is interesting to note that the ideas of taste advocated by Sen no Rikyu have remained almost unchanged for half a millennium, and the appreciation of wabi sabi doggedly remains despite the huge changes in culture and social values. Why has this style survived when almost all others of the same era have been relegated to art history? It may well be a testament to the fact that the beauty of wabi sabi will, because of its profound artlessness and purity, always strikes a chord in the spirit of man, affirming our insignificance in a world in constant flux.

DESIGN

DESIGN PRINCIPLES
OF WABI SABI

WHEN WE SEE something grandiose or physically impressive like the Eiffel Tower, we are moved to a feeling of awe and wonder. How, then, can a person be moved by a single flower in an old bamboo vase? How can this simple expression enable a person to experience a heightened sense of himself and his environment?

There is something in the flower arrangement that manages to condense, into something so utterly simple, a reflection of existence and our lot as human beings. The flower may be just coming into blossom and so signify the force of life, while the vase may be deformed or split showing the signs of decay that define the inevitable path traversed by all things organic. These thoughts may not be verbalized, but something within is touched by the knowledge that we, too, are part of the coming and going of life, and as certainly as we have enjoyed the vigor of youth, we will grow older and move toward the winter years.

Zen monks and tea masters were aware of the effect a well-designed room or garden could have on one's psychological well-being and made every effort to fine tune their arts to maximize these positive effects.

In the modern world, where design reflects the prevalent material aspirations, we live and work in areas that show scant regard for our spiritual nature. Most modern designs lack intimacy, and production costs and shrewd marketing schemes play the dominant role in

defining our living spaces. As an ideology detached from the commercial world, wabi sabi provides an alternative to these poorly designed and mass-produced environments. It can rekindle the dwindling awareness of our own spirituality and bring back a sense of what it means to be human in such an awe-inspiring world. This section will look at the different attributes of wabi sabi and go on to suggest how people living in the West might be able to benefit from the wisdom of the old Zen sages.

PHYSICAL AND METAPHYSICAL PROPERTIES OF WABI SABI

Heralding from a different cultural milieu complete with a radically different cosmic view, wabi sabi presents, in its alien nature, a rather tricky aesthetic to actually analyze within a Western framework. And there is always the danger that overintellectualization, the very thing that it is trying to avoid, will diminish the potential that it hints at. Nevertheless there are certain physical and metaphysical themes that are generally present in most expressions considered to be wabi sabi.

Unlike many Hellenic-inspired concepts of beauty, wabi sabi has nothing to do with grandeur or symmetry; on the contrary, it requires that one should observe, with the utmost attention, the details and nuances that are offered to the keen eye. For it is in these almost imperceptible details that one can find the visual treasures that lie at the heart of wabi sabi, and it is through them that one might be able to catch a glimpse of the serene melancholy that they suggest. The scope of wabi sabi expression is vast and need not be limited to just the visual arts. Poetry, theater, and music are also mediums capable of instilling a sense of wabi sabi, and as is befitting of a Zen-inspired aesthetic, there are no hard-and-fast rules for the physical qualities of wabi sabi.

Indeed, one of its underlying tenets is a quest for the unique and unconventional. However, if one had to suggest one common thread

that is able to link all wabi sabi expressions, then it might be said that those sensitive to its mood should, when coming into contact with wabi sabi expressions, find themselves touched in an indefinable yet profound way. They have a sensation of yearning for something that defies articulation and a sense of peace brought by the reaffirmation of our impermanence.

In the following section we look at some of the properties of wabi sabi design and how they embody the underlying philosophical ideology.

ORGANIC

It is important that some part of every piece of wabi sabi art is organic in nature, whether it be clay, wood, textile, or any other naturally occurring material. The tides of time should be able to imprint the passing of the years on an object. The physical decay or natural wear and tear of the materials used does not in the least detract from the visual appeal, rather it adds to it. It is the changes of texture and color that provide the space for the imagination to enter and become more involved with the devolution of the piece. Whereas modern design often uses inorganic materials to defy the natural aging effects of time, wabi sabi embraces them and seeks to use this transformation as an integral part of the whole. This is not limited to the process of decay, but can also be found at the moment of inception, when life is taking its first fragile steps toward becoming.

Design criteria:
- No shiny, uniform materials
- Materials that clearly show the passage of time
- Materials whose devolution is expressive and attractive

FREEDOM OF FORM

The form of the piece should be personal and intimate with little attention given to symmetry or regularity. Unlike primitive art, which

shares many of the features of wabi sabi art, it is rarely symbolic in any way. The form of the piece is usually dictated by the properties of the material used and the function it provides. An example of this is a bamboo vase. Nature has already provided the shape; it is up to the craftsman to select the most attractive section and to cut it according to the size required. Form should not be a purely conceptual idea of the artist, as this may lead to the involvement of personal tastes moving the work away from artless toward artful, and thus away from the true spirit of Zen.

When being formed, it is important that the artist should be devoid of thought and in tune with the natural rhythms of life. Intellectual ideas of art and beauty are to be discarded as the artist strives to bring out the innate beauty found in nature.

Although one can get a feeling of wabi sabi from naturally occurring phenomena, it is usually the act of framing by an artist that brings the poignancy to the attention of others. As well as making something from scratch there is an abundance of good resources in antiques or secondhand markets, in the countryside, or even on the beach. When a taste is acquired for things wabi sabi, the world can turn into a very interesting place, full to the brim with creative potential. A well-balanced piece of driftwood can add a wonderful touch to an otherwise minimal interior, and all that may be required is the mounting of the piece on the wall or on a tabletop. Quite often what is not added is more important than what is. The discipline of Japanese design is to refrain from embellishment and to let the art work by itself without trying to improve it. Some might argue that the artist must refrain from putting in any of his own personal ideas of taste or style in order that the piece should be free of any pretension or foibles of the ego. Personality, however remarkable, is still no match for nature, and so the stamp of individuality is not seen as being important—there are in fact those who decry it. For the truly great individual artists, who have through their efforts managed to transcend the bounds of their own individuality, their art then becomes

egoless and artless. The great esteem shown to artists who have managed to transcend themselves and make their art artless reflects the intense difficulty of the task. The Japanese seek the enlightenment of the artist in the work that they do, for it is this element that makes some art truly great.

Design criteria:

- Asymmetry or irregularity
- The form comes from the physical properties of the materials used.
- Artlessness not artistry
- The piece evolves in a natural and unforced way.
- No symbolism

TEXTURE

Where a large percentage of modern designs use materials that often have a smooth and sleek finish, wabi sabi expressions tend to use the organic nature of the materials and forms to leave the object with a rough and uneven surface. As nothing in the world we perceive is perfect, the idea of perfection is an unattainable concept that can only be approximated. If we look at any object in enough detail we will see imperfections and flaws that are an unavoidable part of the randomly evolving environment we live in. If an object is supposed to be unflawed then the eye is drawn to and inevitably offended by any imperfections. On the other hand, where something makes no attempt at perfection but yields to the universal laws, then the image sits more comfortably on the eye. The iron surface of an old kettle slowly changes over the years until there is a kaleidoscope of nuances that are pleasing on the eye.

These colors are then further enhanced by the random pitting caused by the corrosion. So although the overall shape of the kettle may be attractive, the real wabi sabi beauty lies in the small details where the passing years have added an extra depth. The mind can

then, without trying to fit the object into any conceptual category, enjoy the randomness and imperfections of the piece and feel in it the imperfections present in our lives. Through the textural variations, roughness, and wear and tear over the years of use, objects can become more expressive and still more appealing.

The examples of textures are almost limitless and include the cracked mud walls of a tearoom, the uneven weave of antique mosquito nets, the coarse feel of an unglazed pot, and even the worn contours of a tool handle. Textural complexity and randomness are essential elements in wabi sabi, for without them the piece will not truly suggest the arbitrary nature of evolution and devolution.

Design criteria:
- Rough and uneven
- Variegated and random
- Textures formed by natural sporadic processes

UGLINESS AND BEAUTY

The words are steeped in emotion as people grow up in societies that deplore the former while adulating the latter. Our ideas of what represents beauty and ugliness are based mainly on learned assumptions about the items that we perceive in our own separate worlds. But, in the Buddhist view of the world, there is no duality, no life, no death, no beauty, and no ugliness. These exist only in the minds of those who are not enlightened and are the ideas we must dismiss if we are to perceive the world that lies beyond that.

As Buddha said, "If in the land of Buddha, there remains the distinction between the beautiful and the ugly, I do not desire to be a Buddha of such a land." It has been said that wabi sabi is the coaxing of beauty out of ugliness, but this seems to suggest that the two ideas are opposing absolutes. Zen would maintain that the two are one and the same and only divided by learned perceptions. The beauty of

wabi sabi is not in the realm of learned ideas of beauty and ugliness, it lies in an intuitive, nonintellectual feeling toward objects that can bring about the wabi sabi experience. The real beauty that we can enjoy in true and pure aesthetics is neither beautiful nor ugly, it is the magical state that happens before any of the concepts have found voice in the intellect.

A knot in a piece of wood may be seen by some as an unattractive flaw that should be cut out, but there are many who find the gnarled tentacles of the knot more appealing than the even grain of the rest of the wood. For some, the lack of order and cohesive symmetry makes things ugly, for they are not so easy to analyze in terms of other known forms or textures. If the mind cannot easily categorize them, then it may find them unappealing and difficult on the eye. On the other hand, seen from a different perspective, the object, because it does not easily yield to a common form, may hold far more potential as it can stimulate new mental activity in much the same way an infant first starts to explore the world. It is precisely the deviation from preconceived notions of beauty that presents a new challenge in the way we perceive an object. Wabi sabi can therefore be seen as both beautiful and ugly, but the resulting emotional response will ultimately depend on the disposition of the audience.

By avoiding any deliberate attempts at classical beauty, wabi sabi focuses on the world before these ideas existed and gently pushes the observer toward this realization. Perhaps the emotions aroused by wabi sabi expressions are reactions to the chords resonating deep within our souls, a resonance of the freedom of early childhood and the call of the eternity surrounding us.

Design criteria:
- Disregard for conventional views of beauty
- An aesthetic pleasure that lies beyond conventional beauty
- Beauty in the smallest most imperceptible details

Color

With the use of natural materials and dyes, wabi sabi rarely strays from the boundaries of subdued colors and lighting, for it is through these that the atmosphere of intimacy can be transferred. In the tearoom, the pastel colors of a mud and sand wall blend effortlessly with the straw used for the tatami mats, the wooden support beams, and the paper screens. Light is let in only to the extent that vision is not impaired by its absence, and the subduing of color provides the most suitable environment for the subjugation of the active mind. In the same way that red is used in fast-food restaurants to discourage guests from settling any longer than is necessary to consume their food, the colors of a tearoom instill a guest with an unusual degree of calmness and serenity. Nearly all things considered wabi sabi have not just one color but a myriad of colors blending together. Unlike modern finishes, the surface is rich with nuance and the flows of colors create the most intricate and intriguing patterns. On careful inspection one can almost get lost in the wondrous flux of colors coming from a slowly rusting iron bowl, a decaying tree trunk, or even a dew-soaked rock.

The textiles and papers used by the tea masters rarely strayed from the ingredients to be found in nature, but large areas of uniform colors as well as any bright colors were always assiduously avoided. While the shoguns and wealthy nobility often favored gold and other ostentatious colors, the Zen monks and the tea masters preferred the more mundane colors such as browns, greens, and grays. They also tended to favor darker shades over light. The colors were often toned down by the medium in which they occurred, such as the mud walls inside the tearoom. The surface is very uneven and there is a degree of inconsistency in the mud itself. The result is a whole spectrum of colors that blend together. Within the cracks and the textural variegations lies wabi sabi, both in the tiny details of the wall and its overall effect on the room.

Design criteria:

- No harsh or strong colors
- Subdued lighting
- Colors and dyes from natural sources
- Diffuse and murky colors
- Matte colors that lack uniformity

SIMPLICITY

As hinted at above, there is a need to focus only on the essential part of the design; beyond its functional requirement no further embellishment should be required. This is one of the cornerstones of Japanese design and one that has stood the test of time while fashions have come and gone. Yanagi called for a return to the crafts where the function and the natural materials used were the sole dictums for design. Nothing more should be required.

Sometimes Japanese art and architecture can seem almost brutally austere, with no quarter given to ornate design ideas, and Yanagi argued that it is here that true beauty exists as a synergy between the unlettered craftsman and the natural raw materials that he uses with such humility. It was indeed these very items that inspired the first great tea masters when they came to fully appreciate the craftwork of the simple-living potters in Korea. With nothing beyond what was required and little premeditation the potter would make his wares without considering artistic expression or personal preferences. The tea ceremony has been called the religion of beauty, and for its top exponents, tea masters like Shukan, Joo, and Rikyu, it was the uncompromising simplicity of these rustic pots that embodied the very essence of beauty. The paring down to the very minimum while still retaining the poetry was the tea masters maxim for design. The discovery of this obscure beauty was the challenge laid down to all those taking part in the tea ceremony.

Once attuned to this peculiarly Japanese way of perceiving beauty, the potential for aesthetic pleasure broadens considerably while the

need to follow the whims of fashion is significantly reduced. This can have a tremendous effect on the environments we choose to live in and the choices we make in our physical lives. With its deep philosophical consistency, wabi sabi offers an alternative to the abject materialism relentlessly touted by the media and offers a more balanced approach to being in a modern society.

Design criteria:
- No embellishment or ostentation
- Unrefined and raw
- Use of freely available materials

SPACE

The concept of space in Japan is more pressing than in most other countries both in physical and metaphysical terms. Physically because the mountainous regions that dominate the landscape severely limit the amount of space available for living—the average size of an apartment in Tokyo is only about forty-eight square yards (approximately 40 square meters). This physical restriction has out of necessity affected the way in which space has been used to maximize its potential. In the traditional house, beds, in the form of futons, are stored in cupboards that are integrated into the wall, and so when cleared away the room provides ample space for other uses. The scarcity of space has made it a prized commodity, so the use of space has formed an important element in the Japanese aesthetic. By keeping artistic expression to an absolute minimum they have managed to maximize its impact.

How Japanese designs use space has also been powerfully influenced by metaphysical ideas about the material world and how people relate to it. *Mu* is the thorny Zen concept not of nonexistence, as the translation of "nothingness" suggests, but rather the passing through to that which lies beyond the dualism of existence and nonexistence. This love of mu is found in the constant use of space

to suggest it. In the open expanses of the gardens, in the broad unused areas of monochrome painting, and in the complete lack of adornment in the tearoom, the Japanese show their reverence for space and the feeling it can instill. When considering wabi sabi expressions, an allowance should be made for space to play an active role. If for example a piece of driftwood is to be placed on a wall, it should be placed on a large, empty pale wall with nothing that will detract from the single piece of wood. This nonclutter requires discipline, and it is often necessary to get rid of all excess in order to give sufficient space to just one expression.

The use of space is not just restricted to the space into which an object is placed, but also the space within it. There is a need to provide visual space so the nonmaterial aspect of the work can interact with and balance its material counterpart. Music has been described as the spaces between the notes, and in art, too, the areas that are not actually used can be just as important as those that are. An English flower arrangement may, for example, take up two thirds of the area directly above the vase with an abundance of extrovert flowers, but a nagaire flower arrangement from the tea ceremony may take up less than one tenth. Again, the space afforded to the single flower forces the attention to focus on the smaller details, and in so doing the life of the flower becomes imbued with far more poetry.

Space and the discipline required to maintain it is a key aspect of the Japanese aesthetic ideals, and when considering wabi sabi designs, the provision of adequate space is an important element that adds so much more than "nothingness."

Design criteria:
- Nothing surplus to requirement
- Significant areas of "nothing" in interiors and gardens
- Ample space around all accent pieces
- Accent pieces at an absolute minimum

BALANCE

Balance and proportions are probably the main reason why so many designers continue to make a living, for it is the almost mystical process of balancing different elements of a design in an aesthetic way that separates the proverbial men from the boys. Of all the elements of design this is probably the hardest to provide guidelines for, and yet it is arguably the most important factor in the outcome of a piece. For example, a joiner had made a shelving unit for a Japanese designer as per the information provided, but when the designer looked at the finished piece, she immediately told the joiner that it had not been made correctly. After protesting that it had been made according to her instructions, a measurement was made and the unit was shelved! A thirteen-centimeter gap, not the prescribed twelve centimeters, was, to the Japanese designer's eye, the difference between right and wrong. This was in fact verified when a new unit was made to the correct specifications. But ask a designer how he or she knows this and one is met with a shrug of the shoulders.

The Greeks had a special formula to decide matters of balance and applied this to many aspects of architecture and design, but needless to say, no such rules exist for wabi sabi designs. In keeping with wabi sabi's centrifugal reference to naturally occurring phenomena, *all aspects of the design must be physically balanced in such a way as to reflect the physical balances found in the natural world.* These natural proportions, which have evolved as being the best suited to the environment, are the yardsticks by which wabi sabi expressions should be designed. It is only by continued observation of the surroundings that a feel for these unwritten rules will become imprinted on the aesthetic judgments of those trying to create. The hard work of creation is in this relentless assessment of the guidelines provided by nature.

The form of most wabi sabi pieces is usually dictated by the function that they are intended to fulfill. There is little history of art for art's sake in the tearoom, as each part of the tearoom and ceremony

are integrated into the function that they perform—the beautifully crafted whisk also whisks the tea beautifully.

The artistic input for the ceremony came from the simple flower arrangement, the hanging scroll, the refined poverty of the interior, and the exquisite movements of the tea master. The Taoists and Zen monks were very practical people, so things without function were often considered frivolous. When considering wabi sabi designs, abstract sculptural pieces should make way for unforced designs that also incorporate an element of usefulness such as a vase, a table, or a teacup.

Design criteria:
- Careful and constant observation of the physical balances found in nature
- No prescribed formulae
- No regular or uniform shapes
- Design elements balanced in a way that looks completely natural and unforced

SOBRIETY

It is an undeniable truth that much of the beauty accredited to the simple lines in Japanese design comes down to the determination to keep both art and everyday designs to a functional minimum. There has been a tendency in the West to make something beautiful and to then spoil it by fussing it up. *Art is sometimes better defined by what is left out than by what is put in.*

On visiting a client's house we saw a wonderful piece of driftwood that had been placed on a plain pale wall. Everything about it was right, the worn colors with a hint of the ship's blue paint left, the holes where joints had been made, and the overall shape. It was an inspired piece, so simple and yet so effective, and such a perfect balance with

the otherwise clean and uncluttered feel of the house. However, when we went back a month later, the piece had been embellished by a few touches of paint to highlight the suggestion of the sea. For us the piece had lost its intrinsic appeal and its purity.

To the Japanese mind, this purity and honesty is vital, as within any design the eye is naturally drawn to a feeling of sincerity. There was a master gardener who noticed an apprentice trimming a hedge while slightly off-balance. The master gardener quickly reprimanded the student, explaining that his lack of focus and effort would mean that this spirit would be transferred to the feeling of the garden. He said that it was vital that everything done in a garden was done in a spirit of dedication and humility, for it was through this struggle that the work would become imbued with spirituality. More than any learned ideas, it was the effort and attitude of the gardener that would decide the outcome of the garden.

This way of making things is not limited to gardening but extends to every aspect of Japanese art. The quality of any piece of art is said to be decided before the pen or brush has been lifted, for it lies within each person, and the art that is produced is only as good as the spirit of the artist at the time it is made. The links between wabi sabi and Zen exist because the monks were well aware that artistic expression is a carbon copy of the awareness of the artist, and if anything of worth is to be made then the spirit of the artist must be the first criteria to be satisfied.

In some ways it is fitting that sobriety forms the last section of the chapter, for it is sobriety that has cut its way through the long history of frivolous materialism, and it is sobriety that lights the way for all the future endeavors of mankind.

Sobriety is a natural extension of the resolute modesty found in wabi sabi thought, and armed with this sobriety and humility Japanese artists, philosophers, and poets have continued to seek the ultimate truth of art and the life that it defines.

Design criteria:

- Reality of impermanence used to add a sense of perspective and finality
- All design work approached with humility and sincerity
- Clarity of personal motives
- All aspects of design kept to a functional minimum
- Pieces that are intimate and personal

CREATING EXPRESSIONS
WITH WABI SABI MATERIALS

HAVING LOOKED at the properties of wabi sabi, we will now go on to ways in which these ideas can be used in modern living. The following section will discuss the different materials that can be used and suggest how these elements might be used to enhance environments we spend time in.

When defining wabi sabi, there are two levels of approach. The very ethereal level where beauty and enlightenment merge, and the more practical level where Zen can guide the artistic aspirations of mere mortals. Although a perfect philosophical understanding of art and aesthetics is an unrealistic goal for most, the art of wabi sabi still has much to offer modern design theory.

In a purist and very Japanese view of wabi sabi, the whole ethos is based on humility toward one's own life and the world at large. This quote from a Japanese potter brings the totality of the wabi sabi philosophy into perspective: "It is nearly impossible to clearly define wabi and sabi. Maybe one could say that it is living unselfishly with our fellow men without desire for profit, resisting ideas of self-importance or status, and humbly accepting our position in life."

Wabi sabi is the aesthetic that comes naturally from this attitude. *The attitude does not come from the art.* It would be incorrect to say that wabi sabi art can be forced or copied, because this would deny its spirituality and its transient nature. As our feelings are in constant

flux so is the world we perceive, and in order for us to catch the fleeting beauty our minds and motivations must be clear and free from the folly that prevails in much of our twenty-first century behavior.

For those inspired by the sentiments of wabi sabi and the potential it offers, there are no hard-and-fast rules on what is and what isn't wabi sabi. If something evokes feelings of an intangible yearning, then that something has wabi sabi for the person concerned. Like all art it is very personal and subjective. However, without recourse to classification or intellectual analysis, the Japanese generally agree on what objects, scenes, or other mental stimuli evoke these wabi sabi sentiments. Using these as a starting point, the following section will look at some of the parameters for wabi sabi designs giving suggestions on ways to they can be incorporated into a modern lifestyle.

MATERIAL CHOICE

Material choice is a key factor in the creation of a wabi sabi atmosphere. The original exponents of wabi sabi advocated the use of materials that occur naturally—mud, clay, wood, bamboo, cloth, paper, hemp, grass, and even iron. The idea was to use materials that were easy on the eye with subdued colors and a propensity to physically change with the passing of time. As most combinations were seen in the environment, there was also a natural transplanting of color and textural combinations. Nearly all wabi sabi expressions require an element of the organic, as without it there is no feel of time and no sense of impermanence. Glass, aluminum, and plastic, because of their uniform shiny surface and inability to express the impermanence of all matter, are generally considered inappropriate materials for a true wabi sabi expression.

WOOD

Japan has had an enduring love affair with wood, as it is eminently well suited to both functionality and aesthetic expression. The tree

grows from a seed and will eventually, over the course of a few hundred years, reach the end of its life and then return to the soil where its decay will sustain other trees. The struggle of the tree to overcome the relentless forces of the environment can be found in its every fiber. Its fight for life, staged over the centuries, is clear in the grains and the knots, in the branches that have striven to catch the energy from the sun and the roots that have sought food and stability in the soil. There are trees with gnarly barks and unique shapes that represent some of nature's most engaging sculptures, for they are the perfection of imperfection.

Apart from some incredibly resilient woods such as teak, most woods, even when cut and treated, will continue their journey back to the nothingness from which they came, and in this passing their colors and hues, grains and figures can provide both beauty and usefulness. For those interested in using wood for wabi sabi expressions, the pieces of wood that are in their most dynamic stages of devolution are often the pieces that have the greatest potential. As the chemical makeup of the cells in the wood change with the passing of decades, the colors become richer and the flaws more pronounced, and for this reason many of the most interesting pieces are to be found among used pieces in reclamation yards. Oak beams that supported a house ceiling for half a millennium, twisted and contorted as the deepest residues of moisture worked their way to the surface, offer incredible potential. It is then up to the artist to take the spirit of the old tree and frame it in such a way as to do its long journey justice.

The cleaning of such beams is like an exploration as the wire brush scraps away the centuries of accumulated grime to reveal the treasures beneath. Once the dirt has been painstakingly removed the smooth parts can be sanded and polished to provide a finish where the rough and smooth provide visual relief for each other. The use of a brushed-on sanding sealer and then a coat of wax helps to impart a patina where the high spots of shine resemble the feel of a piece of wood that as been gently handled for years. The patina is absolutely

critical for the final finish of the piece as it makes all the difference to the visual impact. The eye is very sensitive to these subtle variations, and for a piece to be really appealing every effort must be expended to develop a patina that captures the wood's extended history.

Where many countries in the West have used stone as a primary building block, the Japanese have traditionally favored wood and paper to counter the extreme swings in climate and the ever-present threat of earthquakes. They used wood and paper extensively as walls and room dividers, but unlike other countries the Japanese rarely painted their wood, preferring instead to savor the figures made by the grains. This use of wood and other naturally occurring materials in the building process ensured that the interior colors all remained mute and natural. There was no need to match colors because they had already been perfectly matched on nature's palette. When entering a traditional Japanese interior one of the overwhelming impressions is one of complete unaffectedness and a sense of harmony. Restraint again defines the boundaries and multiplies the overall effect.

On entering a traditional temple or dwelling, it is hard not to notice the many pieces of carefully crafted wood and the attention to detail that has gone into their making and their intricate joinery. For the Japanese carpenter, his work, if it can be called that, is meditative and becomes an expression of true dedication to craftsmanship. Both his tools and the wood he uses enjoy an unspoken reverence, and it is said that a carpenter can spend up to a third of his time sharpening his tools in order that the cuts he makes are as clean and precise as possible. Each piece of wood is as unique as the tree it comes from, with its own potential for beauty. In the mass production of furniture there is a trend to cut out all the wood that does not comply with the design and only keep the part that is considered useful. As a result, the average wastage for an oak board in the U.K. is over fifty percent, but if each piece were looked at for its own merits, then much more of the spirit of the tree might be expressed and less of the valuable source would be wasted.

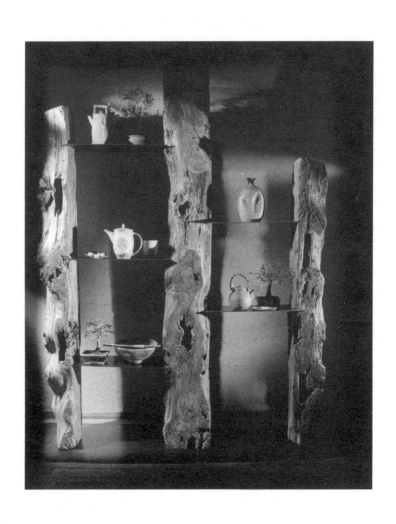

The great American-born woodworker George Nakashima has built his work around the principle that each piece of wood has a perfect use, and it is up to the woodworker to find that use and to allow the tree to live on through his craft. His work revolves around the natural beauty of the wood, and working it in such a way as to give full play to the colors and figures that come from the random flow of wood fibers. If there is a large crack in the wood or a knot, then, instead of cutting it out, woodworkers like Nakashima make it a main feature of the board and encourage the people who look at the piece to enjoy the asymmetry that nature's mark has left. In wood more than any other medium, there seems to be a universally shared appreciation of the figures and flows found within its fibers. And the figurative pattern of a wood such as walnut, with a grain like licorice tentacles that spiral around a knot, can capture and keep recapturing a sense of wonder and awe. Although not expressly called wabi sabi, the furniture of Nakashima and other like-minded woodworkers makes no effort to contain the play given by the wood to the sublime imperfections created by nature.

Uses for wood:

- Flooring. Old floorboards with character are ideal and the best boards are often to be found in reclamation yards. To achieve a good patina the wood must be sanded to a fine finish, sealed, and then polished. Generally the darker the wood the better and some companies even offer flooring cut from large sections of very old timber that has darkened naturally with age.
- Exposed beams and supports. In the tearooms of Japan the room is visually divided by both wooden and bamboo struts, and often the walls are filled in on top of the asymmetrical pattern of the wooden frame.
- Wooden objects such as rustic bowls, vases, lamps, driftwood, interesting roots, and so on. Bowls turned from burr woods such as oak or elm tend to work better, and these burr off-cuts

are often available at sawmills. One can actually take a whole chunk of burr and carve a bowl from the center leaving the outside bark as it is.

■ Furniture (tables, benches, work tops, shelving units). The waney or natural edges left on boards add a visual softener to the lines and give the furniture a more organic feel. A trip to a wood company that cuts their own boards from logs will usually turn up some very interesting board shapes. The furniture can then be made to enhance the natural shape of the board.

■ Furniture from reclaimed sea defense timbers found in docks, ports, and protected seashore areas. Greenheart and other such timbers that have spent years being eroded by the movement of the sea have some exceptionally attractive shapes, and these can be incorporated into interiors or gardens. They can be cut into more usable sizes for making lamps, vases, bowls, and the like; used as accent pieces on their own; or incorporated into other furniture designs. Care should be taken with greenheart as it has an unpredictable grain and an exceptional blunting effect on tools.

■ Furniture from reclaimed railroad ties. Different from the sea defense wood in the way it has been eroded, it can be used in many of the same ways. An example might be a simple bench made by cutting two sections for the legs and then using the rest for a bench top. A wide variety of timbers have been used for railroad ties ranging from treated pine to teak. Untreated hardwoods are more pleasant to work with and generally have more attractive patinas. Also care should be taken to avoid any grit or stones that have become lodged in the wood.

■ Bamboo crafts for internal fittings, garden dividers, vases, lamps, and so on. There are many kinds of bamboo including an attractive black bamboo that can be used in place of poles such as curtain rods. When using bamboo it is important that it has been well seasoned to reduce splitting. Scorching the bamboo

with a flame darkens the bamboo and can add greatly to its visual appeal.

METAL

Metals containing iron are very vulnerable to corrosion and color changes, and as they are radically different in feel and texture they provide a good contrast to the other more naturally occurring materials used in wabi sabi. The iron kettle used in the tea ceremony is an example of the way in which the beauty of metal's impermanence is highlighted and prized. With the passing of the years the slow corrosion on the metal's surface will become more pronounced, as will the vast array of subtle hues within the surface. The range of colors this produces and the resultant pitting of the surface epitomize wabi sabi, and although the Chinese characters are different, the Japanese word for rust is actually sabi. However, a plain rusted surface alone is not the desired finish, as the oranges are too strong. It is the very slow unforced change of color that is sought, and this is a process that cannot be hurried.

One current artist in Japan uses metal sheets taken from the hulls of old ships and then cuts them to blend with the pieces of wooden furniture he makes. The sheets are all carefully cleaned with a wire brush so that all excess rust is removed and then protective oil is added.

Among other metals that lend themselves to a wabi sabi feel are wrought iron and zinc. Wrought iron and cast iron are difficult to work, but some of the pieces that have been discarded have excellent potential for wabi sabi designs. They have already been through the aging process and have all the depth of color and texture required for incorporation into wabi sabi designs. Before the dawn of stainless steel, zinc was used for its nonrusting properties, but over a long period of time it naturally darkens as it oxidizes, leaving a very attractive patina. Conran furniture designers have developed a way of chemically accelerating this process and market tables whose patina has a very wabi sabi appearance.

Metal on its own can be a little harsh and lacks intimacy, but it has a natural affinity with wood. Wood is far easier to work three dimensionally, and the two textures offer a great many combinations.

Uses for metal:

- Furniture (particularly with wood). Sheets of old metal can work well as shelves. Other pieces found in metal recycling yards can form legs or even tabletops. Quite often a visit to such places may provide the inspiration for a piece of furniture and the wood can then be cut to fit the qualities of the metal.
- Recycled mechanical, construction, or nautical iron used as part of a functional design. Oddly shaped vessels have excellent potential and can serve as a base for a lamp, a flower vase, or even a fruit bowl.
- Wall hangings. Highly corroded sheets of metal with multiple layers of decay and rich textural patterns can be very attractive when mounted on a plain wall. A coat of oil often helps to bring out the colors and to retard any further corrosion.
- Heat-treated steel that changes color with high temperatures or charcoal firing used as part of a functional design or as a wall hanging. When steel is heated to high temperatures interesting patinas can appear on the surface. There is also a process where stainless steel heated in charcoal yields an attractive black matte finish. Large flat sheets will be prone to warpage if unrestrained.
- Chemically altered metals used as part of a functional design or as a wall hanging. Chemical reactions leave sporadic and random patterns on a metal surface. This is quite a specialized field but there are a number of ways in which a surface color can be achieved on metals to soften their appearance. An idea that has been incorporated in our own design work is a treatment for mild steel where the sheets are chemically blackened and then sanded with a very fine wet and dry sandpaper and lubricating oil. In the forging of the metal sheets the finest of patterns is left

on the surface, and this only becomes apparent when the black surface is partially removed. The random nature of the mottled effect and the subdued black color of the sheets have worked well as a contrast to the more random forms of woods such as oak. (See illustration of shelving unit.)

- Hand-beaten sheet metals formed into utensils. An example of this might be a 4 mm-thick square sheet of character steel (found in a reclamation yard or the like) beaten into the shape of a bowl.

Paper

The number of handmade papers available in Japan is staggering, and the tradition stretches back through many generations. In the West there was, until more recently, the prevalence of the idea that paper was a medium for the recording of information or as a base for other types of artistic expression. In the East, however, there has been a long held reverence for the intrinsic beauty of handmade papers, made as they are from a huge variety of natural ingredients in a wide variety of styles. In 1928 there were no less than 28,532 Japanese families involved in the business of traditional paper making who supplied the huge demand for decorative and architectural purposes.

Made without the use of bleaches or other chemicals, the papers capture the many textural and visual nuances of the natural ingredients and become a unique and rich tapestry. The delicacy of the paper belies its intrinsic strength, and in this delicacy and randomness of form one can find some very wabi sabi nuances. The properties of paper have long been exploited by Japanese designers, including Isamu Noguchi, whose groundbreaking lamp designs have become a well-known feature in houses throughout the world. Paper's lightness and translucence, coupled with its ease of molding, gives artists the opportunity to use this economic resource in a multiplicity of ways. These properties of paper are used in the making of shoji, or screens, which, in the tearoom, allow just enough light to enter but ensure

that it is diffused and unobtrusive. This lighting effect in the tearoom adds immeasurably to the whole ambience as everything within the room is bathed in a soft and soothing light. In addition to these shoji screens, good-quality paper has also been used for the scrolls that were hung in the tearoom and as a base for monochrome pictures.

Uses for paper:

- Screens. Although there are specialist papers available in Japan for the making of shoji screens, thin handmade papers can have a very similar effect. The frames can be carefully manufactured or made from more organic shapes.
- Wallpaper or coverings for unattractive surfaces. Applied in the same way as wallpaper in a patch quilt style, it has the effect of breaking down some of the visual solidity of the walls. The natural colors of the paper and the textural variations can bring a sense of warmth and intimacy to a room.
- Framed wall hangings.
- Bases for other art. Some modern Japanese artists are now using strong natural paints on a heavily textured paper, and the unevenness of the surface adds a further complexity to the picture.
- Table mats. A thick handmade paper cut into place mat sizes is an excellent way to add a more intimate feel to a table setting.
- Light filters/lampshades. A thin handmade paper that is reasonably translucent can be wrapped around a wooden or metal frame in either a symmetrical or asymmetrical shape to diffuse the harshness of a light source.

TEXTILES

Although Japan is probably better known for the peerless silk work involved in the making of kimono, there still exists a cult of textile appreciation that emphasizes tactile and visual complexity. The wabi sabi aspect of fabrics is to be found in the coarse weaves and the use

of traditional natural dyes such as persimmon, tea, saffron, onion, and indigo. These dyes are applied to such materials as hemp, silk, and cotton, and a wabi sabi–style result is best achieved by allowing a degree of randomness in the process so that there is an almost imperceptible stream of color change throughout the piece of fabric. The dyeing process also allows the hand of nature to weave its spell into the fabric so, as with all natural mediums, there is a degree of imperfection that can be seen and savored.

There are several artists in Japan, among them Kumozawa Fujiko, who use textiles to produce wall hangings and room dividers. Kumozawa uses *kaya*, an antique mosquito net made from handwoven hemp, as a base and then adds a variety of natural dyes. These are then either framed or weighted at the bottom.

A surprisingly good source of wabi sabi textiles comes from less economically developed countries and in particular the African continent. The use of natural dyes and the hand weaving of the materials ensures that the textiles have an added dimension of interest lacking in the consistency of most modern machine-made fabrics. The Zaire cloth shown in the illustration on the previous page, although a little more symbolic than pure Japanese work, is a good example of the materials available. Its randomness and rawness are in perfect balance with the faded organic colors. The African, who made it many decades ago, was probably closer to the spirit of wabi sabi than a lot of present-day tea practitioners, and the unaffected African spirit comes through every fiber of this cloth.

Uses for textiles:

- Loose or framed wall hangings. For example, one could clamp an attractive piece of cloth between two bamboo halves and hang it on a plain wall with some hemp twine. Weights sown discreetly into the bottom help to keep the material in place.
- Room dividers. The Japanese often separate spaces not with doors or full-length curtains but with material dividers that

come down from the ceiling to about chest height. These have the effect of visually separating areas without a door.

- Furniture upholstery/curtains. By incorporating interesting textures and natural dyes, interior spaces feel less sterile and more nurturing.
- Tatami floor mats. The traditional flooring for Japanese houses although not expressly wabi sabi in their design, can bring an overall feeling of naturalness to a room and tend to complement other accent pieces.
- Clothes. Keeping to the principles of subdued colors, natural materials, and simple lines, it is very easy to bring a feeling of wabi sabi to the wardrobe. In Japan there are many designers who use the aesthetics of wabi sabi to increase the appeal of their clothes.
- Table runners and place mats.

STONE

Although rarely seen in Japanese interiors, rocks and stones have played a fundamental role in the evolution of the Japanese aesthetic ideal. The shapes carved by nature over millions of years make rocks and stones some of the oldest physical items in our world, with some dating back way beyond our ability to conceive of the vastness of the passage of time. Melted deep within the earth, caught up in ice flows, pounded by rivers, eroded by rain, and ravished by extremes of heat and cold, rocks represent the most amazing resilience to the elements and yet even the hardest granite must eventually yield to the omnipotent forces at large. Maybe in part it is the clash of these two great forces and the work that has been done by nature over countless millennia that makes rocks so magnetic in their appeal. The extremes they have undergone are written both on their surfaces and through their cores and can be literally entrancing. Not ones to miss such an obvious truth, the Japanese incorporated rocks heavily into their

garden designs and also developed an art form called *suiseki* (water stones), which essentially involved the mounting, on a carved wooden pedestal, of interesting rocks that had been found in the countryside. However, the use of flat stones or mined stones has been limited by the preference of wood as a building medium, and so the use of processed stones, other than those carved for garden ornaments, has been fairly limited. In Tokyo today one can see the expensive marbles and granites used for tower block facades, but there is still only limited use of stone for interior decoration, and considering its potential and the Japanese love of things *shibui* (literally "bitter" or "astringent") this seems a little surprising. This may in part be explained by the limited usefulness of stone for interiors and the Japanese criteria of function before form.

Lying between the two extremes of polished marbled and naturally occurring rocks there are stone surfaces that are almost audible in their wabi sabi appeal. The hand-riven surface of slate for example, with its myriad hints of green, gray, and iron orange laying on and between the entwined layers, forms a picture in its own right. These engaging properties can be used in conjunction with other mediums, such as wood to make inlaid tabletops and other work surfaces. A sanding of the untreated surface followed by a couple of coats of oil (finishing oil works well) will leave a very attractive and durable surface.

Uses for stone:

- Table tops, work surfaces. Granites, sandstone, slates, and limestone all work well. Instead of using a highly polished surface, a riven or honed finish is preferable because of the matte quality. Stonemasons often have slices of quarried stones that still have their natural edges with some very interesting shapes.
- Integral parts of furniture. A slab of slate or sandstone cut square can be inlaid into a wooden surround to make a coffee table. Stone suppliers often sell these kind of slabs in pre-cut sizes.

- Flooring and tiling. There are now an abundance of different natural stones available in tile form that can add a natural feel to floors or tiled walls. The old flagstones found in English cottages are a perfect example of how the uneven worn surface of the stones can complement an interior.
- Contemplation stones (natural stones/rocks that have a pleasing shape). These can be found out in the countryside. Carboniferous limestone, igneous rocks, and also rocks found in the desert are well suited to the aesthetics of wabi sabi.
- Garden features. Large rocks strategically placed in either gravel or vegetation and asymmetrical stepping-stones have long been used in Japanese garden design. When designing a Japanese garden in the U.K. we found a large stone whose shape, texture, and color we particularly liked, but it was difficult to use in its original form. We asked a stonemason to cut it in two and then to hollow out the top of one half so that it could be used as a water feature in the garden (see the illustrations on pages 70 and 72).

CLAY

Clay holds center stage in the history of wabi sabi, and although a degree of knowledge is required to mold and fire clays, there are still an abundance of interesting pieces that can be bought either new or secondhand. As discussed in the section on pottery, there is a deep-rooted dedication to pottery in Japan, and every conceivable effort has been made to bring its aesthetic potential to full fruition. To undertake the study of Japanese pottery is a long-term commitment, and mastery in Japan may still be difficult to transplant to other countries. However, for those interested in finding wabi sabi pieces of pottery, there are a variety of sources that exist outside Japan, and seeking them out can indeed be an exciting affair. As wabi sabi is primarily interested in the artless and the humble, the first port of call, as with textiles, are the countries where local craft is often a substitute for modern technology.

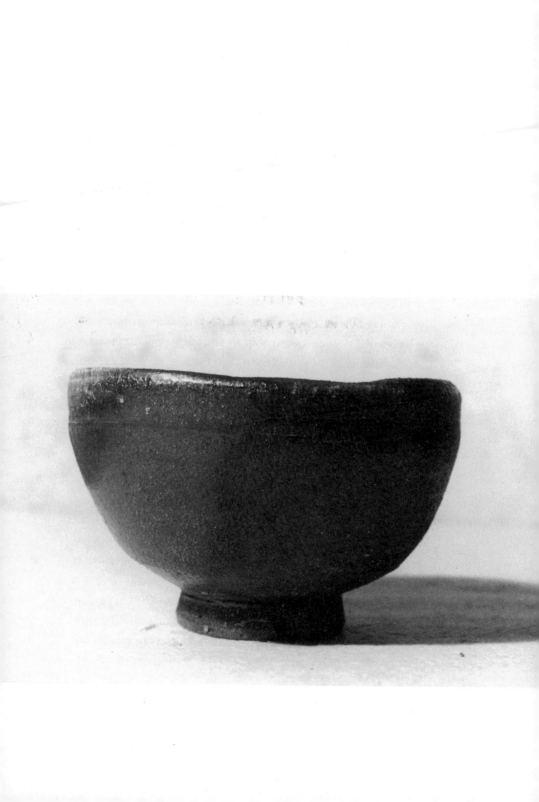

When looking for wabi sabi pottery either overseas or at home the following are guidelines on what to look for:

- Functional rather than decorative
- Rough and organic feel
- Little to no defined design
- Dark, mute colors, preferably with a natural ash glaze
- Complexity in color and texture
- Naturalness and ease of use

We have now looked at the many different aspects of wabi sabi design, its physical and metaphysical properties, and the materials most often used, but the question still remains of how Japan's most elusive aesthetic can be brought harmoniously into a Western framework.

Bringing the feeling of wabi sabi into a modern environment is as easy as it is difficult. The first and most important aspect of wabi sabi is the mental attitude toward both art and life. It presents the enormous challenge of reassessing at the most fundamental level our attitude toward our environments, our fellow men, and ourselves. When our impermanence highlights the absolute irrelevance of material gain and when we can see our lives with a sense of humility and equanimity, then we are ready to see the beauty that lies within the subtleties. As the aesthetic grows and strengthens, we start to relish the artless and the mundane. This then extends into all aspects of life—into relationships with others, our choice of occupation, and the environments we choose to live in. Slowly and without premeditation we incorporate more and more of the wabi sabi aesthetic into our living spaces until they become a natural extension of our own love of the humble and unadorned.

Like the philosophy of Taoism, where wabi sabi finds its earliest roots, there is a need to approach wabi sabi design gently and with respect. The principle of wu-wei, or not forcing, is the catalyst for this slow and natural adoption of a wabi sabi view of the world.

This personal journey has the potential to bring a greater harmony between the spiritual beings we are and the material world in which we live. The living environments that evolve from this understanding will help to nurture our sensitivity toward the world and to promote a deeper shared appreciation of the artistry of nature.

SPIRIT

THE UNIVERSAL SPIRIT OF WABI SABI

ALTHOUGH THE TERM *wabi sabi* has become associated with Japan, the sentiments that it fosters are universal, and the fundamental feelings of all mankind have certain shared emotions that exist regardless of cultural boundaries. While the expression of these sentiments may vary from culture to culture and indeed from person to person, there remains a thread of commonality that binds all humans.

In the West there is an undeniable tendency to avoid too much speculation about our inevitable passing, yet the sentiments of impermanence and an appreciation of things wabi sabi have found voice in many of the world's artistic expressions. People are often drawn to the melancholy suggested by things wabi sabi without really questioning why. We are drawn to poems of longing, the haunting call of distant bagpipes, and the solitary Muslim call to morning prayer; we are inspired by the beauty of the ancient cobbled streets of a medieval French town or the aging waterways of Venice. They are all considered beautiful in the way in which they instill a sense of the serene—a beauty without need for splendor. And despite the emergence of a pop culture there still lies deep within us an innate longing for arts and environments that will help to put our perceptions back into some sort of perspective.

It is through these varied mediums that people of different cultures gently remind themselves of their intrinsic fragility and use these sensory cues as a springboard for attaining a more profound sense of themselves, helping to see through the folly that pervades

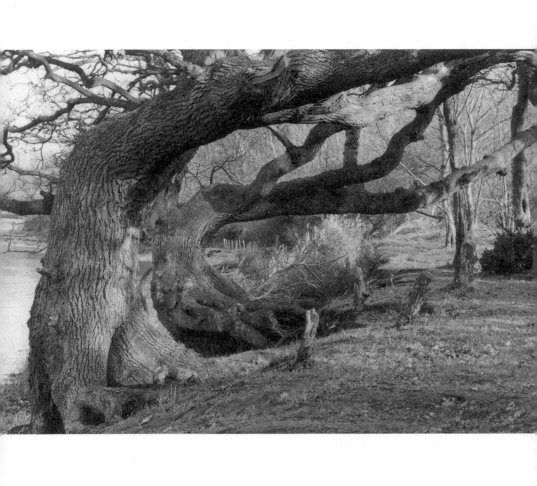

much of daily life. It is the uncompromising touch of death that can put a keener edge on our appreciation of life. The Japanese, along with many other cultures, have long understood the value of this and have sought through the arts to promote and share this awareness.

Where the Japanese people may have differed in the past is in the completeness of their devotion to all arts that embody the essential reference point of impermanence. Through their earnest endeavors in matters of the spirit they have managed to refine their art forms so that they are worthy reflections of the mystery that we know as life. Their dedication to paring away all that is not necessary, of reaching the real heart of the matter, has yielded great spiritual rewards that are more than evident in the art of the spiritual masters. The enlightenment that goes into their work still sparkles with wisdom and magic—for they were able, through their art, to point the way toward the Buddha, toward freedom.

In the West we have now achieved a degree of affluence unimaginable a century ago, but this material wealth is leaving in its wake an acute spiritual vacuum in which many are struggling to find a real sense of meaning and purpose.

The struggle for physical survival has all but lost its relevance in first world countries, but without it we now require a new focus for life. And more and more this is to be found in the world woven by the marketing gurus—a world of eternal youth and wealth, a world of fantasy on which to pin our hopes and dreams. There was a marketer who, when asked about his profession, said that he was in the business of making people unhappy, of making them buy what they didn't need. It is now the media who have an omnipotent say in how we see ourselves. How scary and undesirable is that? Yet the fact remains that we all need meaning in order for our lives to have a sense of purpose, and it is the media and advertisers who hold a great sway on our meaning structure. However, without this sense of purpose we could find ourselves adrift in the sea of indifference and apathy, and this is one of the great dilemmas facing mankind in this age.

On the one hand, life without a sense of meaning is for most intolerable. As Albert Camus said, "Man is a creature who spends his entire life trying to convince himself that his existence is not absurd."

But on the other side of the argument, Okakura Tenshin points out that this focusing on the meaning of our lives tends to make us too heavy and self-important, "How can one be so serious with the world when the world itself is so ridiculous?"

Few people are ready to take on the proposition that their own existence is ludicrous, but at the same time the media version of what we should be aspiring to is equally lacking in substance.

Can artists show the way to resolving one of the greatest challenges mankind has ever had to face? Contemporary art seems to have moved so far beyond the original concept of art that it may be time to reassess the art of days gone by, when the artist, whether he was a composer, poet, designer, or philosopher, earnestly struggled to bring some sort of spiritual value to his work. It may now be time to stop chasing the unattainable dreams of commerce and focus again on what is important for us as human beings.

Wabi sabi, as a tool for contemplation and a philosophy of life, may now have an unforeseen relevance as an antidote to the rampant unraveling of the very social fabric, which has held men together for so long. Its tenets of modesty and simplicity gently encourage a disciplined humility while discouraging overindulgence in the physical world. It gently promotes a life of quiet contemplation and a gentle aesthetic principle that underscores a meditative approach. Wabi sabi demotes the role of the intellect and promotes an intuitive feel for life where relationships between people and their environments should be harmonious. By emboldening the spirit to remind itself of its own mortality it can elevate the quality of human life in a world that is fast losing its spirituality.

The Wabi Sabi Environment

"The heaven of modern humanity is indeed shattered in the Cyclopean struggle for wealth and power. The world is groping in the shadow of egotism and vulgarity." —Okakura Tenshin, 1906

THE PRESSURES on the environment brought by the exponential increase in world population and the rising demand for consumer goods has had serious implications for the welfare of planet Earth. To keep economies buoyant and shareholders happy, people are being encouraged by politicians and marketing agencies to consume at an ever-increasing rate. This may seem like a good short-term solution for economic growth and increased GDP figures, but as the demand for the limited resources are not sustainable, a more realistic approach will soon become necessary.

There are many different groups, with a mixture of philosophical backgrounds, who are actively promoting a more balanced approach to managing the world's finite resources. But all agree that there is a need to rethink, in a fairly radical way, the way we interact with the ecosystem that is vital for our future survival. Modern science has brought incredible benefits to the marketplace, not least of which are the many breakthroughs in medicine over the last few decades. However, the use of nondegrading plastics and other man-made pollutants, coupled with the rampant consumerism of the last thirty years, has meant that waste is now a critical issue. In Japan, where *tsukaitsute no mono*, or disposable products, have been extended to

such items as cameras, umbrellas, phones, and even bicycles, the mountains of semitoxic waste are being produced at a rate sufficient to fill a baseball stadium every day.

Where does wabi sabi come into this? There are in fact three ways in which the philosophy of wabi sabi relates to environmental issues:

- Minimizing consumption
- Choosing quality products that come from sustainable organic sources
- Respecting nature

The most radical nonmaterialism is continued today in the monasteries around the world, where monks and nuns take on the bare minimum required for a healthy life, sometimes owning a bowl, a robe, and little else. These ascetic lives are chosen in order to attain enlightenment, and any material possessions are seen as an impediment. There was a monk in China called Yunmen who, when he decided that he would take up the life of an itinerant monk, threw all his worldly possessions into the river, instead of giving them away, so they would not encumber anyone else.

True wabi sabi has inherited much of this sentiment, and the life it promotes puts little store in the accumulation of wealth or objects. The tea masters chose the rustic pots and the tiny modest hut as their symbols of beauty, and in so doing rejected all the finery and fashions in vogue with the ruling classes. Swayed by the Buddhist movement and the austerity of the temples, the wabi sabi lifestyle had little space or desire for material possessions. There is a little irony in the fact that this complete rejection of the high-class tea utensils turned the nobility into avid collectors of wabi sabi pots. They became much prized and very expensive and exactly the opposite of what Rikyu had perhaps intended.

Freedom from the desire to possess new objects is indeed a wonderful release, and it was at the center of Buddhist teachings. However, after his stint of extreme asceticism, the Buddha advocated the

middle road, not indulging in excess but living in harmony with the natural world. This harmony with nature was also a major theme in Taoist thought, and this has been incorporated into the wabi sabi worldview. Wabi sabi treads a fine line between enjoying the beauty of things while knowing that they are as transient as everything else.

The philosophy of wabi sabi stresses that it is not through material possessions and worldly attachments that we will be able to find the peace that we seek. Instead of demanding consumer goods, so many of which are designed to become obsolete in order to perpetuate sales, we might choose to only buy what we really need for a fulfilling life. Here is where the consumer choice of wabi sabi has significance for environmental impact.

The focus could be on the quality of the products and the sustainability of the resources used in their manufacture. Instead of the media, through the barrage of advertising, constantly reinforcing the idea that we actually need the latest device for painlessly removing nasal hair or anticellulite electronic muscle toners, they might apply there formidable resources to something more meaningful.

Idealistic as this sounds, the power of the media to change consumer behavior in a positive way can be seen in the case of the U.K.'s organic food consumption. In keeping with the laws of the market economy, the farmers have invested great efforts to meet the huge rise in demand for organic produce. Here, inspired largely by the media, we see a huge swing toward a more healthy way of eating and a more natural process for farming—and all this happened in the free market as people have become more concerned about the safety of the food they are eating.

If, in the same way, people's demands for more organic and environmental products increase, then the impact could only be beneficial for all the world's inhabitants, and it is here that the consumer has great power to influence the products being offered on the shelf. Each individual shopper is, with every shopping decision, voting for one product over another, and the sum of these votes alone will deter-

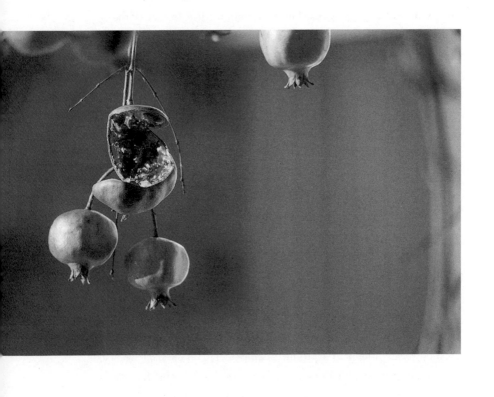

mine the activities of suppliers to the market. If enough consumers demand that a product, such as a table, be made so that its design and structure can withstand the test of time, then the market will provide such a table. If the design is simple but elegant and the quality of the manufacture is high, then the table should last generations and its appeal should increase with the passage of time as the colors deepen with the patina of use and age.

As a consumer voter each individual has the opportunity to influence the market, and although in isolation the effect may be insignificant, the voices of many individuals will create a huge force that has the power to support the future well-being of the environment.

The final way that wabi sabi promotes a better environment is in attitudes toward nature. As Ryokan shows in the next chapter, in the heart of the humble there is a great love for all aspects of nature, whether they be the magnificent beasts that walk on the Serengeti or the lice the monk played host to. This respect for nature fosters a caring attitude toward it, and rather than seeking to gain from its exploitation there is an active desire to conserve and replenish the environment.

Through their considered purchases, a preference for quality over quantity, the use of organic materials over modern, less environmentally friendly materials, and a spirit of conservation, those drawn to the life of wabi will be able to make a positive contribution to the well-being of the planet. If key persuaders in a society take up the baton and manage to get the media ball rolling, then our attitude toward the world as a place to freely plunder may change and we may learn to treat it with the respect it deserves.

THE LIFE OF WABIZUMAI

"Attach your lives to a goal not people or things." —Albert Einstein

BUDDHISTS SAY that the idea that desires can, if given sufficient means, be satiated and appeased is an obvious fallacy, and that beyond one desire lies an inexhaustible line of others. The only true way, then, to find a state of independence from the demands of the physical world is by ceasing to need more than is required. By only taking what is really needed to maintain physical health there is then freedom from the relentless desire to have anything more. The scope of this freedom is far-reaching, because it then opens the way for a simple life without the need to chase dreams of wealth or sensual gratification. Freed from these desires, a person should be able to find peace and not need to invest so many hours of the day in pursuit of goals that yield only transient satisfaction.

In most Western countries, despite the huge technological developments that have negated the need for many aspects of manual labor, people are working harder and longer than ever before, and this has arguably detracted from the quality of their lives. There have been few checks on the encroachment of a purely material world and hedonism has been slowly replacing the function of religion. The acquisition of material wealth has become increasingly important, as it is often associated with happiness. The part played by the media in developing this tenuous link cannot be overestimated, but by throwing the focus of life into the arena of the material world,

the importance of the spiritual world is then relegated to second place. The spiritual world is intangible, and so in its nature has little potential to offer the commercial world, but now, as a result of this, we are facing some unattractive social side effects. Depression is said to affect one in five in the U.K., with one in six Americans having been prescribed Prozac. Overindulgence in the physical world is evidenced in the ever-increasing obesity problem; this in a world where many are still starving.

Alarm bells should be ringing loud and clear, but as the answer is not politically or commercially palatable little will be done by business or the state to improve the situation. There is an urgent need to reconsider our aspirations and goals in a more holistic light and to look toward a future that will provide for our psychological needs in the same measure as for our physical ones.

It is obviously impractical to suggest that everyone should don a monk's robe, shave their heads, and move to a hermitage in the hills, but there is much to be learned from the simple lifestyles of the monks who lived a life of wabi, referred to as *wabizumai*. (*Wabi* here means solitary and simple and *zumai* being a verb extension meaning to live.) These Zen monks, who had overcome their worldly desires, lived in the simplest of huts often in challenging conditions, but in place of physical comfort they enjoyed a peace of mind and a true appreciation of life that seems to be lacking in the helter-skelter of modern life.

The famous monk Ryokan, who for many epitomizes the life of wabizumai, owned his robe and a begging bowl and little else. Ryokan felt that the life being pursued by men in the towns and cities, including many of the monks in the temples, held no real value for him, so he decided to leave their world and live a life consistent with his own beliefs. As with all great struggles, there were times of extreme hardship and solitude, the sentiments of which he captured in the following poem:

Sometimes I sit quietly,
Listening to the sound of leaves falling,
How peaceful the life of a monk is,
Detached from all worldly matters,
So why do I shed these tears?

Still, his love of nature and life was legendary and endeared him to all he came into contact with. He had been educated in the Chinese and Japanese classics, but he studiously avoided intellectualization and formalism and instead sought the simplicity and clarity of a child's mind.

The blue sky and the bright sun in the first days of spring,
As all around becomes verdant and fresh.
Carrying my bowl I amble onwards towards the village.
The children, surprised to see me,
Joyfully gather around so bringing
My begging trip to its conclusion by the temple gate,
I put my bowl on the top of a white rock,
Hang my bag on the branch of a tree,
And then play with a ball and the wild grasses
For a while we play catch as the children sing,
And then I take my turn.
Playing with abandon I loose all track of time.
People passing by point and laugh asking,
"What is the reason for such foolishness?"
I respond only with a deep bow,
For even if I answered it would be beyond their
 understanding,
Look around, there is nothing more than this.

It was this living and thinking without clutter that Ryokan advocated, and when he saw the rather egotistic and academic tendencies in those Buddhist monks who indulged in learning or other affairs

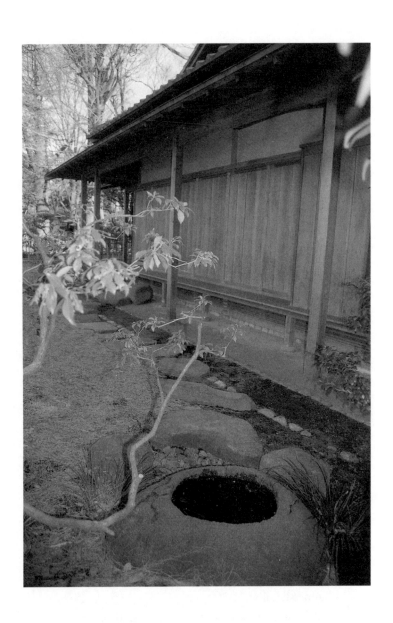

of the intellect, he would write poems that parodied their own self-importance.

With his intense respect for life, Ryokan's behavior was, by today's standards, a little eccentric, and he even went so far as to warm his pubic lice by placing them out in the evening sun. He also managed to set fire to his hut while trying to burn a small hole in the roof for a bamboo shoot to pass through. But despite his quirky habits, the purity of his spirit gave his calligraphy such depth and energy that it was prized by all. Some of the local merchants who were aware of the profit to be gained from such works would try to trick the monk into writing on anything that came to hand. He once wrote a message on a kite that has since become a national treasure.

Being immersed in the Zen view of impermanence as Ryokan was, when he was asked for some special calligraphy that would bring the family good fortune the monk wrote the character for *shi* (Death). The surprised recipient could not understand why such an unhappy character should be written, but Ryokan explained that "When people are mindful of death, they don't waste time or squander their wealth."

However much the antics of this monk may appeal to our sense of romance, the relevance to life in a modern city is a little hard to perceive at first. Where Ryokan lived in the humblest of huts in the hills, most people today live in comfortable houses in congested cities, and where Ryokan spent his days on his begging rounds, helping in the villages, and playing with children, today lives are generally jam-packed with work and social commitments. And yet despite the cavernous cultural and historical divide between the life of a nature-loving monk and that of today's city dwellers, there still remains in most of us a craving for the simplicity that such a life represents.

There seems to be a dichotomy between the lives we are constantly told we should be living and the simple life that for many holds a greater appeal. Put another way, there is a choice for most in the West between hedonism and wabizumai. The wabizumai road, well-signposted by Zen (as well as most other religious movements),

is a personal path and involves a personal choice. On the other hand, hedonism is the accepted norm and claims to offer the easiest and most comfortable passage through life. Wabizumai is an ascending path full of potholes and bends, but it is a path that has the potential to take the spirit to a higher level. While hedonism tends to be more appealing, it often leads to a lowering of spiritual resolve. Zen maintains that it is effort and discipline that will bear fruits, and if we in the West wish to benefit from this wisdom then there must be a move away from the pervasive goal of instant gratification of the senses. The transition toward a simpler lifestyle, fraught as it is with difficulty, is a path only for those with a resolution to travel its length knowing that it is a path without end, yet a path with heart.

GLOSSARY

Chado—The way of tea.

Chaniwa—The tea garden.

Chanoyu—The tea ceremony.

Chashitsu—The tearoom.

Chaya—The tea house.

Furyu monji—Literally "can't stand on words or letters." A Zen phrase meaning that one should not put any store in words or language as they are unable to transmit the wisdom of satori.

Kami—The Shinto idea of gods or powers that manifest themselves in the world we perceive that can affect and guide the lives of men. There can be kami in a rock, in a hanging scroll, in a tree, in ancestors, or in the lives of great men.

Koan—Literally "public cases," they were riddles set by the Rinzai sect of Zen as a way to direct one's concentration during meditation. An example of a koan is "What is the sound of one hand clapping." By focusing on something that has no logical solution, the acolyte is forced to broaden his mental horizons until they are ready to break the boundaries of perception and attain satori.

Mono no aware—Literally "an intense feeling of things." An ancient term that enshrines the Buddhist idea of ephemerality. Used in art criticism to convey a sense of beautiful sadness or gentle melancholy. Its links with the beauty of impermanence make it a very close relative of the term *wabi sabi*.

Muga—Literally "no self," denoting the state reached when self-effacement is attained.

Mujo—Literally "not forever." A constant theme in Japanese literature; reiterating the ever-present Japanese sensitivity to the transience and mutability of life.

Mu—Literally "nothingness." A central theme in Japanese philosophy that does not refer to a state of nonexistence but rather to the absolute transcending of all ideas of existence and nonexistence that is paired to the state of enlightenment.

Mushin—Literally "no heart." A term used to describe the innocent state of a child and used by the Buddhists to denote a freedom from desire and also the state of total absorption in a task where the reasoning mind ceases to function. It is another way of expressing the self effacement of muga and is a necessary stepping stone on the way to satori.

Satori—Literally "understanding." Refers to the all important realization of our latent enlightened nature. In Zen teaching, the satori experience is always an instantaneous event that relies on an intuitive grasp of reality rather than a verbalized interpretation.

Seppuku—Literally "cut stomach" and is the preferred pronunciation for harakiri (written the same way). It refers to ritual suicide that was done as an act of protest or at the command of a lord.

Shibui—Literally "bitter" or "astringent." A widely used term that has been used since medieval times to denote things of refined and simple taste. It has very close links with wabi and sabi, but its range of use is far more extensive and has now become a popular word to describe things or even behavior as cool.

Further Reading

App, Urs. *Master Yunmen*. Tokyo: Kodansha, 1994.

Britton, Dorothy. *A Haiku Journey*. Tokyo: Kodansha, 2002.

Castaneda, Carlos. *Tales of Power*. Middlesex, England: Penguin, 1974.

Ferrier, John Louis. *Art of the Twentieth Century*. Paris: Chêne-Hachette, 1999.

Goldsworthy, Andy. *Wood*. London: Penguin, 1996.

Gooding, Mel. *Song of the Earth*. New York: Thames and Hudson, 2002.

Graham, Gordon. *Philosophy of the Arts*. New York: Routledge, 2001.

Herrigel, Eugene. *Zen in the Art of Archery*. London: Penguin, 1985.

Hsuan, Ko. *Tao Te Ching*. New York: Samuel Weiser, Inc., 1995.

Kakuzo, Okakura. *The Book of Tea*. Boston: Tuttle Publishing, 1956.

Koren, Leonard. *Wabi Sabi for Artists, Designers, Poets and Philosophers*. Berkeley, Calif.: Stone Bridge Press, 1994.

Mathiesson, Peter. *Nine Headed Dragon River*. New York: Flamingo, 1987.

Munsterberg, Hugo. *Zen and Oriental Art*. Boston: Tuttle Publishing, 1994.

Nakashima, George. *The Soul of a Tree*. Tokyo: Kodansha, 1988.

Osbourne, Peter. *From an Aesthetic Point of View*. London: Serpent's Tail, 2000.

Richie, Donald. *A Lateral View*. Berkeley, Calif.: Stone Bridge Press, 1992.

Stevens, John. *Zen Masters*. Tokyo: Kodansha, 1999.

Suzuki, Daisetz T. *Zen and Japanese Culture*. Princeton: Princeton University Press, 1970.

———. *Sengai: The Zen of Ink and Paper*. Boston: Shambhala Publications, 1999.

Suzuki, Shunryu. *Zen Mind, Beginners Mind*. Tokyo: Weatherhill, 2001.

Tamaru, Noriyoshi, and David Reid. *Religion in Japanese Culture.* Tokyo: Kodansha, 1996.

Watts, Alan. *The Spirit of Zen.* New York: Grove Press, 1958.

———. *What Is Tao.* Novata, Calif.: New World Library, 2000.

———. *What Is Zen.* Novata, Calif.: New World Library, 2000.

Yanagi, Soetsu. *The Unknown Craftsman.* Toyko: Kodansha, 1989.

Permissions

**Grateful acknowledgement is made
for permission to reprint the following:**

Text on page 18 from Suzuki, Daisetz; *Zen and Japanese Culture.* Copyright © 1959 by Bollingen Foundation. Reprinted by permission of Princeton University Press.

Photographs on pages viii, 16, 32, 54, 84, 90, 96, 104, 108, 122, 130, 134, 139, and 146 by Richard Lally.

Photographs on pages 8, 23, 60, 152, and 158 by Yuko Nagai.

Photographs on pages 38, 70, and 72 by Carl Pendle.

Photographs on pages 78 and 126 by Paul Wilson.

Photograph on page 114 by Kuniko Juniper.

Haiku on the back cover reprinted from *Japanese Death Poems* with permission of Tuttle Publishing. © Charles E. Tuttle Co., Inc. 1986.